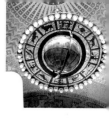

MW01098516

DOWNTOWN in DETAIL

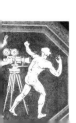

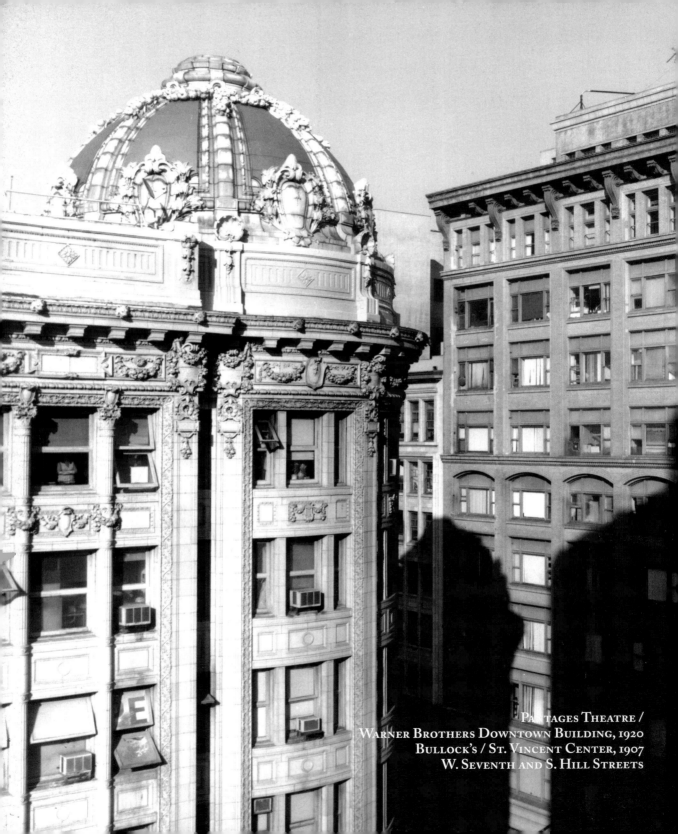

PANTAGES THEATRE /
WARNER BROTHERS DOWNTOWN BUILDING, 1920
BULLOCK'S / ST. VINCENT CENTER, 1907
W. SEVENTH AND S. HILL STREETS

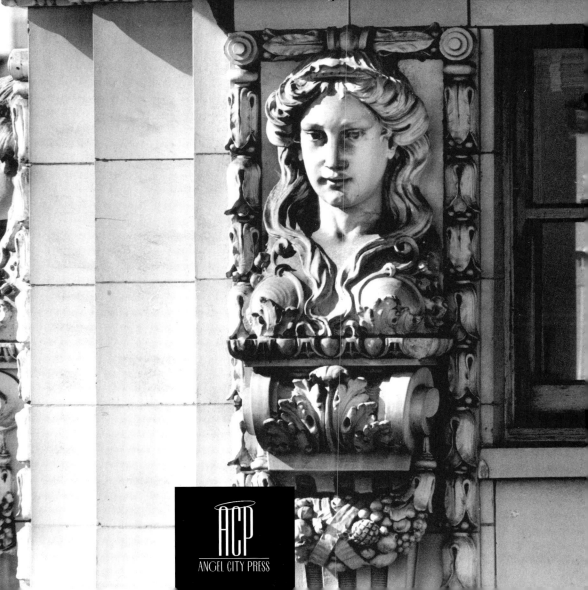

DOWNTOWN in DETAIL
CLOSE-UP on the HISTORIC BUILDINGS of LOS ANGELES

TOM ZIMMERMAN • **Foreword by LINDA DISHMAN**

ACP

ANGEL CITY PRESS

Downtown in Detail
Close-up on the Historic Buildings of Downtown Los Angeles

by Tom Zimmerman

Copyright © 2009 by Tom Zimmerman

10 9 8 7 6 5 4 3 2 1

ISBN-13 978-1-883318-91-8 / ISBN-10 1-883318-91-2

All rights reserved. No part of this book may be reproduced or transmitted in any form or by any means, electronic or mechanical, including photocopying, recording, or by an information storage and retrieval system, without express written permission from the publisher.

Names and trademarks of products are the property of their registered owners.

Design by Amy Inouye, www.futurestudio.com

Library of Congress Cataloging-in-Publication Data

Zimmerman, Tom.
 Downtown in detail : close-up on the historic buildings of downtown Los Angeles / by Tom Zimmerman ; foreword by Linda Dishman.
 p. cm.
 Includes index.
 ISBN-13: 978-1-883318-91-8 (trade paper w/flaps : alk. paper)
 ISBN-10: 1-883318-91-2 (trade paper w/flaps : alk. paper)
 1. Los Angeles (Calif.)—Buildings, structures, etc. 2. Historic buildings—California—Los Angeles. 3. Los Angeles (Calif.)—Pictorial works 4. Los Angeles (Calif.)—History. I. Title.

F869.L88A29 2009
979.4'94—dc22
 2009013791

ANGEL CITY PRESS
2118 Wilshire Blvd. #880
Santa Monica, California 90403
310.395.9982
www.angelcitypress.com

ACKNOWLEDGMENTS

Several people have been instrumental in helping me get the access needed to pursue *Downtown in Detail*. My predilection for taking close-ups of downtown buildings started when I was working on the Central City project for the Community Redevelopment Agency with Rick Starzak and Leslie Heumann for Roger Hatheway. When I asked if he wanted details to go along with the overall photos he said, "Sure." Roger also bought me Rex, the Wonder Camera (a Pentax 6×7) with which most of these photos were taken, and let me work off the cost. Dozens of building managers and business owners let me climb on the roof of their buildings or use their windows and fire escapes. Restoration artist Jeff Muller got me into any building he was working on. Jay Oren of the Cultural Heritage Commission had me photograph several downtown monuments. Several projects for the Los Angeles Conservancy gave me free rein to crawl about in historic buildings. Tara Jones and Guido Hamacher got me into several buildings through their Historic Consultants, Inc. Tom Gilmore hired me to document the development of his Old Bank District and encouraged the project. And thanks to the whole Angel City Press family—Paddy Calistro, Scott McAuley and Lynn Lundstrom—for constantly finding ways to improve the book. Special thanks go to Amy Inouye of Future Studio for the inspired design of this book.

For Roger Hatheway

Who in 1980 asked if I ever photographed buildings,
changed my life and has been a friend ever since.

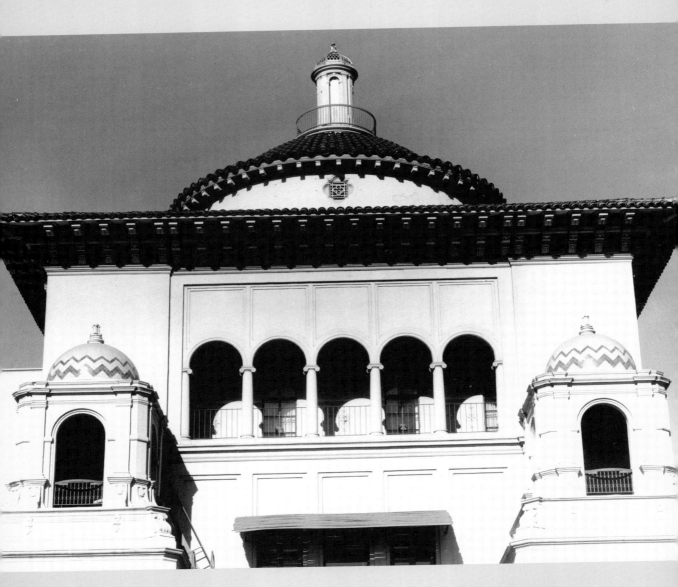

HERALD-EXAMINER BUILDING, W. ELEVENTH STREET AND S. BROADWAY, 1914

Julia Morgan designed the new home of William Randolph Hearst's *Los Angeles Examiner* when it moved from Second and Broadway. The *Herald* merged with the *Examiner* in 1962; both went under in 1989, but the building remains in its glorious almost-original state.

CONTENTS

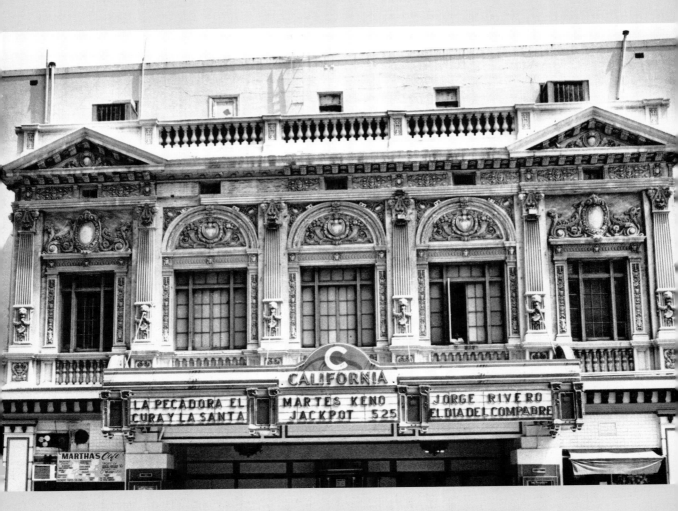

CALIFORNIA THEATRE, W. EIGHTH STREET AND S. BROADWAY, 1918
(PHOTOGRAPH 1977, DEMOLISHED)

The California was the first theater Frank Fouce converted into a Spanish-language movie house. Later, he would buy the Million Dollar and make it the home of Mexican vaudeville in Los Angeles. Since 1978 when it was established, the Los Angeles Conservancy has been working to protect historic buildings like the California.

FOREWORD

P eople who work or live in Downtown Los Angeles are exposed daily to the architectural riches that Downtown buildings provide. Because of my work with the Los Angeles Conservancy, I personally have explored almost every building in what's come to be known as Downtown's Historic Core—very broadly, the area between Pershing Square and Main Street, from Third to Ninth Streets. Like any pedestrian who loves beautiful buildings, I relish the details I see as I lift my eyes up from street level. Conservancy volunteers constantly point out these unique features on our walking tours—a beautiful door here, a mural or magnificent tile over there.

Tom Zimmerman's wonderful images for *Downtown in Detail* do what the Conservancy tries to do: help people see historic Los Angeles in new ways, simply by taking a closer look. We have to know what's out there before we can protect it. Tom truly cares about the roots of our great city and the very special buildings that embody our history. In addition to highlighting the remarkable artistry and craftsmanship in these treasures, his photographs open up a whole new world of Downtown. They show what's hidden in plain view at the tops and inside of buildings, details that many of us haven't seen before.

While there's a sea of faces all around us on the sidewalks of the city, who would know that scores of sculpted faces look down from the façades of our Downtown buildings? The ladies on the cover of *Downtown in Detail* are just a few of them; after seeing the photos in this book, I want to find them all. As often as I have seen the Roxie Theatre on Broadway, I've never seen it the way Tom did through the eye of his camera, as he perched on the eleventh story of a building across the street. What a treat it is to see the penthouse of the W.P. Story building at Sixth and Broadway, a place where its original owners once dwelled. Each image in these pages offers a new perspective, a new view, a new reason to protect these and other time-honored buildings.

This book is much more than a window into the past. The vast majority of buildings pictured are still here, right now. I hope you'll take these photos as inspiration to go Downtown and see them firsthand.

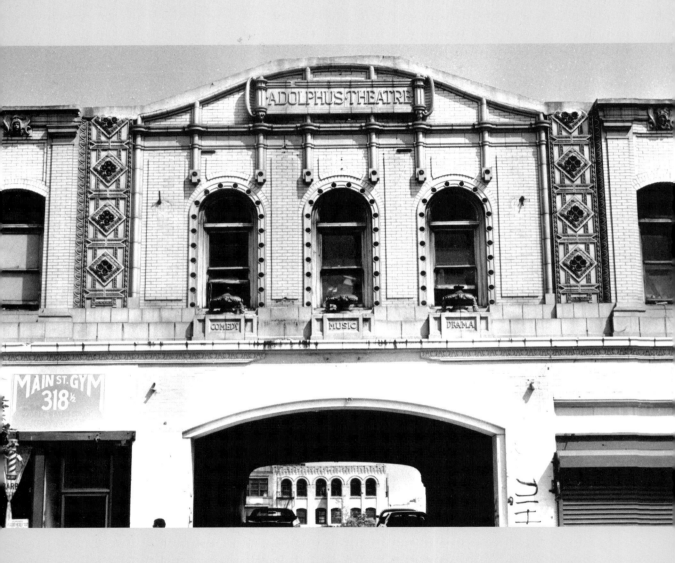

**ADOLPHUS THEATRE / MAIN STREET GYM, 320 S. MAIN STREET, 1911
(PHOTOGRAPH 1976, DEMOLISHED)**

The 2100-seat Adolphus later became the Hippodrome. Eventually the ground floor was demolished for a parking lot, while the second floor became the Main Street Gym.

Some have been revitalized; others wait to be renewed. Some, like the Central Library, serve the same purpose they did when built; others have found new lives with new uses.

Fortunately, we have a highly intact Historic Core, rich with Beaux Arts and Art Deco buildings from the early twentieth century. They stand as unique and tangible reminders of Los Angeles as it came of age as a modern city. And with Tom Zimmerman's remarkable photographs, we see the details that are there, waiting for each of us to rediscover, enjoy, and preserve for future generations.

LINDA DISHMAN
Executive Director
Los Angeles Conservancy

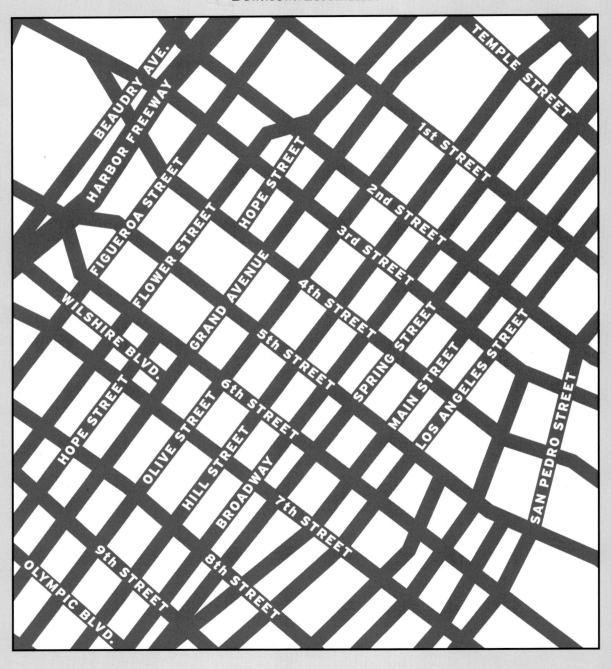

INTRODUCTION

L os Angeles has the most intact pre-World War II downtown in the United States. While the rest of the country was eviscerating its central cities in the 1950s and 1960s, downtown Los Angeles had already lost out to accelerating suburbanization. Several buildings on Bunker Hill and near the Harbor Freeway on the west side of Downtown were demolished in the late 1960s, but there was no reason to tear down the Historic Core because there was no desire to build anything new there.

When the central city began its slow path to revival in the 1970s, the majority of the new construction replaced historic structures on the western side of Downtown—Olive, Grand, Hope, Flower and Figueroa streets. The Historic Core—Main, Spring, Broadway and Hill—was being drained of tenants, but at least it was partially protected. In 1979, the Broadway Theater and Commercial District from Third to Ninth Streets and the Spring Street Financial District from Fourth to Seventh Streets were accepted on the National Register of Historic Places. This made demolition difficult, but not impossible. Main Street was not protected as an historic district and has been decimated.

By the late 1970s, the Historic Core was intact, but largely vacant. Main Street had become a series of bars, flophouses, porn shops and parking lots. Spring Street grew increasingly deserted except for its hotels. At street level, Broadway was the thriving center of Latin American culture and retail. But the buildings were empty above the second floor. The south end of Hill Street above Sixth Street was rescued by the burgeoning jewelry district that took over its buildings and theaters while the north end collapsed. It was not until the first decade of the twenty-first century that the long-abandoned buildings of the Historic Core finally were used other than as background for movie and television productions. In 1999, the Los Angeles City Council passed an Adaptive Re-Use Ordinance allowing the conversion of former office buildings to living quarters. This was a key stimulus to the current loft revolution. The office buildings constructed from 1908 to 1935 generally were still there to be resurrected as apartments and condominiums. They were in definite need of a good cleaning and electrical updating, but still there.

EMERGENCE OF THE CENTRAL CORE (1876-1904)

The pueblo of Los Angeles was planned in the late eighteenth century according to the already two-centuries-old Spanish Law of the Indies, which called for a central commons with homes, businesses and a church being built around it. The first land boom took place in the 1870s fol lowing the arrival of the Southern Pacific Railroad. A much larger rush happened in the 1880s when the Santa Fe Railroad

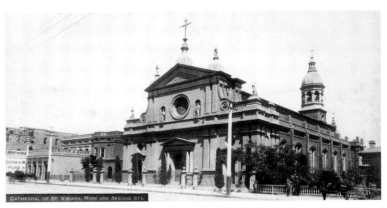

St. Vibiana's Cathedral, E. Second and S. Main Streets, ca. 1910

opened a second transcontinental line into town. The central business core of the late nineteenth century expanded south of the original plaza. It was the only way to go: A series of hills blocked off the west and north while the mighty Rio Porciúncula, renamed the Los Angeles River, blocked the east.

The Central Core slowly gained stature and volume as the downtown streets were served by streetcars beginning in 1873 and were finally paved following the boom of the 1880s. In this period, Los Angeles was little more than an agricultural county seat and the center of a vast number of health seekers' sanatoriums. The civic core was growing, however, and several significant buildings were erected in the nascent city. St. Vibiana's Cathedral on Main Street is one of the few structures that remain from that era. Abandoned by the Catholic Church following the 1994 Northridge earthquake, in 1876 it was like a European cathedral in its dominance on the low-slung skyline of Los Angeles.

There are few businesses remaining from this earliest period. One is Los Angeles' first skyscraper, the 1904 Braly Block/Continental Building at Fourth and Spring Streets, designed by John Parkinson in a particularly top-heavy example of

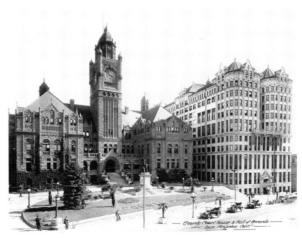

Los Angeles County Courthouse and
Los Angeles County Hall of Records,
W. Temple Street and N. Broadway, ca. 1922

the Beaux Arts style. The plain, brick exterior of the 1893 Bradbury Building at Third and Broadway does not prepare a visitor for the ornate atrium basking in Southern California sunshine through the huge skylight. An open-shaft elevator runs up the five stories past oak balustrades, French wrought iron, Mexican-tile floors and Belgian-marble staircases.

APEX (1904-1935)

Los Angeles hit its stride by the third decade of the twentieth century. In thirty years its population catapulted from sixteenth largest in America to third. Its man-made harbor became the second busiest in the nation. It remained America's leading agricultural county and moved up from twenty-sixth in manufacturing to number eight. Los Angeles became home to the most glamorous industry in the nation when movie studios put down roots in Hollywood, and the region was suddenly a leader in the most modern industry when the same climate that drew filmmakers attracted airplane manufacturers.

The central city continued to expand both vertically and to the south and west. With the construction of the Braly Block in 1904, city leaders started contemplating the need for a building height limit law. Denver, Seattle, Baltimore, Boston and Chicago all had laws restricting how tall downtown buildings could be. Los Angeles was particularly serious about limiting height since the entire spirit of the city was driven by sunshine and open spaces. The last thing anyone wanted for Downtown was New York City-style darkness and congestion caused by overwhelming structures. The Los Angeles Height Limit Law was passed in 1904 and amended in 1911, restricting buildings to 150 feet with a provision for roof designs or advertising to increase

Garnier Building,
425 N. Los Angeles Street, 1980

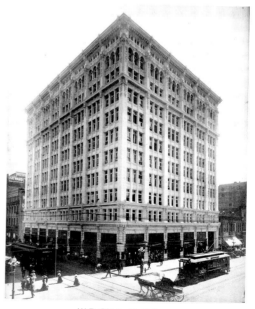

W.P. Story Building,
W. Sixth Street and S. Broadway, 1908

the height. This led to impressive signage such as the vertical neon sign on the late, lamented Richfield Building or elaborate sculpture such as the metal work camouflaging the smokestack on the Eastern Columbia Building. Los Angeles clung to its law long after the New York City setback law of 1916 offered an alternative to the strict limitation of height. The L.A. Height Limit Law remained in effect until 1957.

The style common to what were labeled "Class-A Limit Height Buildings" was predominantly Beaux Arts. This called for an elaborately decorated base and top with a plain central section connecting them. The cladding was almost universally terra cotta, which allowed for very fanciful ornamentation. The 1908 Story Building at Sixth and Broadway by John Walls and Octavius Morgan is an excellent example of the style. The exterior gleams in white terra cotta with heavy marble and ornate stained glass and metal work in the lobby. Mullen and Bluett clothiers occupied the ground level on L.A.'s principal shopping street, while offices filled the structure. The Los Angeles Trust and Savings Building is one block west at Sixth and Spring Streets. Of particular note are the classical busts of female figures lining the topmost façades of both primary elevations.

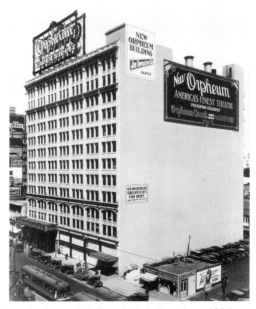

Orpheum Building, 842 S. Broadway, 1926

By the late 1920s, the zigzag patterns of Art Deco started to appear Downtown. Claud Beelman was the architect for three Deco masterpieces in 1929–cross-street rivals: the Eastern Columbia and the Ninth and Broadway Buildings, and the Garfield Building a block away at Eighth and Hill. John Parkinson, by this time in partnership with his son, Donald, designed the classic Title Insurance Company Building on Spring Street.

At its pre-World War II apex, Downtown was the major entertainment center for the city. After 1910, Broadway was its main locus, superseding the original theater districts originally near the Plaza then in the 1880s and 1890s on Main Street. The Theater District eventually spread from Third to Tenth Streets (Tenth Street was renamed Olympic Boulevard in honor of the upcoming 1932 Olympic Games), becoming a mixture of movie palaces seating more than two thousand patrons and smaller first- and second-run houses. The palaces had various takes on historical allusion, but all adhered to architect S. Charles Lee's dictum concerning theatrical opulence: "The show starts on the sidewalk."

The Civic Center clinched the dominance of Downtown by keeping political power in the same

area as the financial, commercial, retail and entertainment centers. By 1931, the state, county and city offices were all within a block of each other. In that year, a WPA Moderne state building on First Street joined the 1891 Richardsonian style County Building right around the corner on Spring Street. A stolid nineteenth-century City Hall on Broadway at Second Street was replaced by a structure designed by John Parkinson, A.C. Martin and John Austin across the street from the County Building. Their concept called for a twenty-eight-story building. It would be over twice the height limit, and its construction had to be approved by a ballot measure. City Hall opened in 1928 and was everything the city wanted to be at that time. It was obviously modern in its design but still had historic allusions in its bas-reliefs. It was also gleaming white terra cotta, enormous by L.A. standards and visible from all over the basin.

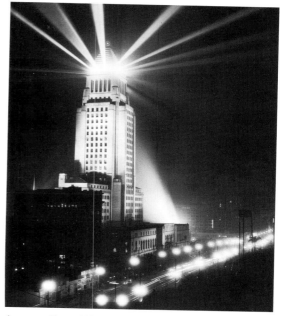

Inauguration of the Lindbergh Beacon, City Hall, 1928

For many years, the "most luxurious" hotel in the city was always Downtown, but each new hotel that earned that superlative was west of the last. For instance, in May 1901, William McKinley was the first U.S. president to visit Los Angeles, and he stayed at the Van Nuys Hotel at Fourth and Main. By 1919, when President Woodrow Wilson was in town trying to sell the American people on the League of Nations, he spent the night at the Alexandria on Spring Street at Fifth. The Biltmore at Fifth and Olive Streets was the scene for the fourth Academy Awards ceremony in 1931.

DECLINE (1935-1960)

Los Angeles has always been a horizontal rather than a vertical city; this preference contributed to the central

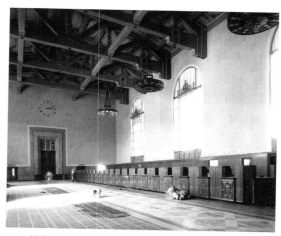

Union Station, 800 N. Alameda Street, 1939

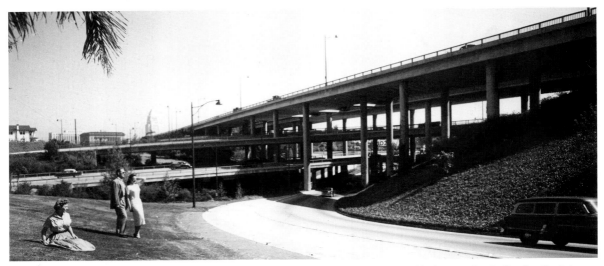

Hundreds of downtown buildings were demolished to build the freeway system that was going to finally alleviate the problems of traffic in the central city. The Four-Level Interchange, 1953

city's gradual decline. First the trolley lines and, by the 1920s, the highways for the increasingly dominant automobile snaked all over the Los Angeles basin. That decade would see the population of the city double to more than a million. There were more autos per capita in Los Angeles than in any other city in the world. The centrality of Downtown to all aspects of Los Angeles life meant the Central Core was choked by traffic. The Hollywood subway, which cut under Bunker Hill to unite the central city with Hollywood and the San Fernando Valley, was built expressly to reduce downtown surface street traffic. But it, along with parking meters and parking structures, did little to clear the overcrowded streets.

Not surprisingly, the trickle of leading shops and entertainment centers vacating the central city in the 1920s became a flood by the end of the 1930s. The Ambassador opened on Wilshire in 1921 and competed with the Biltmore downtown as the city's most elegant hotel. Bullock's flagship store at Seventh and Broadway remained when a magnificent Art Deco-inspired new store designed by John and Donald Parkinson opened in 1929 on fashionable Wilshire Boulevard. Signifying the emerging dominance of automobiles, a trolley line was never placed on Wilshire, and the main entrance to the new Bullock's Wilshire was not from Wilshire, but through an ornate *porte cochere* from the parking lot behind the building. Other leading clothing and accessory shops spread along Hollywood Boulevard between La Brea and Vine.

Sid Grauman also abandoned Downtown. He built the Million Dollar Theatre on Broadway and Third in 1918 and the Metropolitan at Sixth and Hill in 1923. The locus moved west when he built the Egyptian in 1922 and his renowned Chinese in 1927 on Hollywood Boulevard. Grauman had developed

the prologue, which was a stage show that preceded a first-run movie, and the premiere that allowed fans to see and scream at the stars when they arrived at his downtown theaters. But they became famous in the new primary theater district: Hollywood.

Growth did not cease entirely in the central city. Sunkist and Edison built adjacent headquarters at the base of Bunker Hill at Grand. After years of fighting, a terminal for all passenger lines entering Los Angeles was constructed on Alameda Street. Opening in 1939, it was a unique mixture of Spanish Colonial and Art Deco elements and was the last major train station built in the United

For years the Central Core was little more than a major part of the Big Backdrop. Here Main Street is set-decorated as Central Avenue for *Devil in a Blue Dress* (1995).

States. But despite the new Union Station and the 1938 Spanish Colonial Terminal Annex Post Office across Macy Street from it, Downtown was clearly in decline.

NADIR (1960-1972)

The Historic Core on Main, Spring, Broadway and Hill slipped farther and farther from dominance following World War II. Retail radically decentralized as suburban shopping centers sprouted on Sepulveda Boulevard in Westchester, Ventura Boulevard in the Valley, Del Amo in the South Bay and just about everywhere else. The massive downtown department stores on Broadway and Seventh Streets—Bullock's, May Company, Robinson's—began the tailspin that would result in their eventual closings. Only the growing Mexican and Central American population of the city saved Broadway. Shops catering to Latin tastes and needs opened up and down the street. As neighborhood theaters began closing all over the East Side, the movie palaces began showing Mexican movies and vaudeville, or American movies with Spanish subtitles, to cater to the same audience. The same fate for local houses in the predominantly African American South Central Los Angeles resulted in the State Theatre at Seventh Street becoming the chief venue for black-themed films.

The hotels on Los Angeles and Main Streets were the first to become home for low-income and transient populations. Those on Spring, Broadway and Hill Streets soon followed. Legal and financial firms abandoned Spring Street, the former "Wall Street of the West," for Hope, Grand and points west. The buildings sat completely empty since they never had the retail outlets at street level so common to

Broadway. Some efforts were made to modernize the buildings by altering the street level or lopping off a cornice, but nothing stopped the westward movement of money and power. By the 1980s, the only business flourishing along Spring Street was the movie location business. Whatever the city may be to its citizens, to Hollywood producers Los Angeles has always been the Big Backdrop.

The only elements to retain their Downtown dominance were the Stock Exchange and the Civic Center. In 1986, the original Exchange on Spring Street was replaced by a new building west of the Harbor Freeway on Beaudry Avenue. City Hall remained the center of Los Angeles government. The police department left it only to build a new headquarters across Main Street. The Victorian Hall of Records was torn down to be replaced by a new structure built right next to it, which was derided at the time as "Honeycomb Modern." The saving grace for most of the Central Core was that there was no reason to tear anything down. Nobody wanted the property.

RENAISSANCE (1972 to Present)

The focus of Downtown moved to its western side by the late twentieth century. Several buildings breaking the former height limit were constructed on the numbered streets with immediate freeway access. But the key buildings were the fifty-two-story ARCO Twin Towers at Fifth and Flower which opened in 1972. The tragedy was that one of the finest buildings in Los Angeles, the black-and-gold terra cotta Richfield Building, was torn down to make room for these twin monoliths. The importance of the new buildings isn't reflected in their insipid design. Atlantic Richfield Company's chairman Robert Anderson made a significant commitment to locate the newly merged company in downtown Los Angeles and build a massive new headquarters.

The ARCO Twin Towers started the very gradual rebirth of the central city. The Broadway Plaza on Seventh Street, and its attendant hotel, signified a hoped-for return of retail stores and hotels to Downtown when it opened in 1973. The west side of the central city also saw the first significant rehabilitation projects of historic buildings. Developer Wayne Ratkovich bought the Fine Arts Building on Seventh Street and the Oviatt Building on Olive, and with the meticulously researched work of preservation architect Brenda Levin brought both back to life as office buildings. The Biltmore was not allowed to go the way of the Alexandria. Foreign investment paid for a series of rehabilitations and additions starting in 1987. Bunker Hill was the opposite story. The Hill was stripped of the Victorian-era houses and apartments that graced it, flattened by earth movers and planted with a series of high-rise office buildings.

The Music Center signified a commitment to keep the arts Downtown when it opened in 1964. This was furthered by the 1983 "Temporary Contemporary" Museum of Contemporary Art on Central

in Little Tokyo and its 1986 permanent home on Grand. The country's only Museum of Neon Art has stayed Downtown moving from the Arts District to Olympic and finally to Fourth Street. The Los Angeles, Palace and Orpheum Theatres have all been rehabilitated and are ready to anchor the proposed theater district in the works for Broadway. The 1999 Staples Center on Figueroa and the 2007 Nokia Center across the street on Figueroa offered major downtown venues for concerts and sports.

The Historic Core was the final component in the Downtown renaissance. As far back as 1983 the Van Nuys Building on Spring Street at Seventh was turned into low-cost housing. In 1995, developer Ira Yellin converted the Million Dollar Building at Third and Broadway into apartments. In 2001, Tom Gilmore started work on his plan to convert the entire block between Fourth and Fifth Streets and Main and Spring Streets into the Old Bank District. He built them and they came. This opened the floodgates. Scores of long-empty, classic office buildings are being converted into apartments and condominiums. Slowly, a street life is developing in the central city. An art gallery district has developed along Main and Spring Streets between Second and Eighth Streets. Restaurants and bars have opened. When Ralphs supermarket opened at Ninth and Flower Streets in 2007, it marked the first acknowledgement by a chain food store that people were actually living Downtown again and there was money to be made. After decades as Hollywood props, the buildings of the Historic Core are key elements in the renaissance of Downtown, and components in the constant effort by Los Angeles to provide housing for its always-expanding population.

Buildings are plastic things. If the foundation is sound, you can change the interior around to suit changing needs. A 1904 office building like the Braly Block/Continental Building makes a wonderful, ornate apartment house. The 1898 Douglas Building at Third and Spring incorporated as much of the historic structure as possible when it was converted to a highly successful condominium project. The buildings of the early twentieth century had faces. Now that they are being given new life in the twenty-first century those faces are still there to be appreciated by all of us.

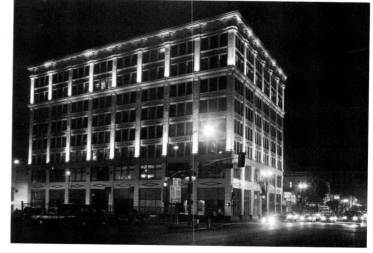

San Fernando Building,
W. Fourth and S. Main Streets, 2002

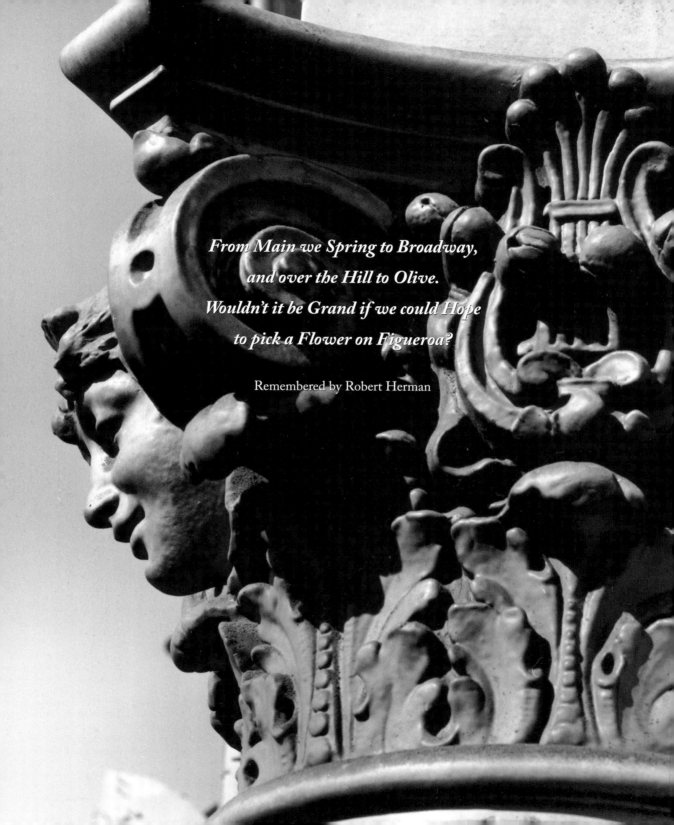

From Main we Spring to Broadway,
and over the Hill to Olive.
Wouldn't it be Grand if we could Hope
to pick a Flower on Figueroa?

Remembered by Robert Herman

THE DETAILS

The figure on the top floor of the Palace Theatre Building has good reason to smile and want to play some music. After three decades and more of neglect, the Downtown Historic Core that surrounds him is being revitalized and he has lived to see it.

The photographs in this book provide an introduction to the buildings from the early twentieth century that still exist in Los Angeles' central city. They follow the Downtown streets as they run from east to west—Los Angeles Street to Figueroa—and from north to south—First Street to Olympic. The images, like the buildings, are concentrated on Spring Street and Broadway. Because the buildings were put on the United States Department of the Interior's National Register of Historic Places, they survived into the twenty-first century largely intact. Savor those buildings.

But don't stop there. Follow the map in the book and explore the historic structures further west. Like their counterparts in the Historic Core, they are not meant to be modern. They predate the International Style with its hostility toward ornamentation. The pre-war buildings were constructed during an architectural era when decoration was encouraged and admired; their forms were not necessarily designed to follow their functions; they were meant to be pleasing to the eye—assets to their environment, not just something planted on the street. The photographs are not an exhaustive list of the historic buildings, nor are they by any means an exhaustive look at all the details that make Downtown such an inspiration. They are merely an introduction. And, they are my invitation to you to explore, to discover, to consider and to help preserve Downtown.

—T.Z.

Orpheum / Palace Theatre, 630 S. Broadway, 1911

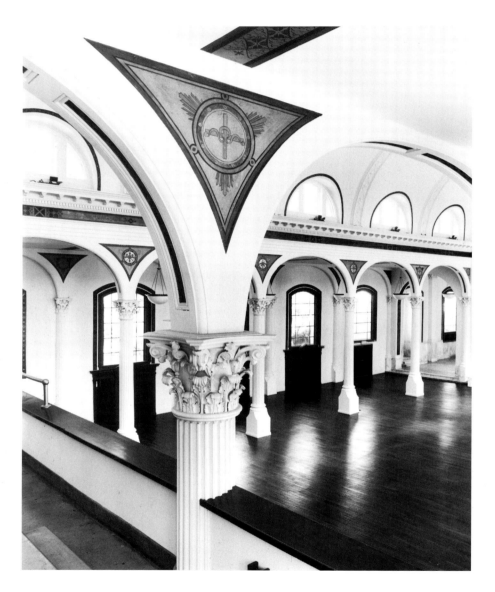

ST. VIBIANA'S CATHEDRAL, E. SECOND AND S. MAIN STREETS, 1876

Saint Vibiana was an Italian teenager murdered by Roman troops for her Christian faith. Her remains had recently been discovered in the catacombs of Rome when the time came to name the new cathedral in the obscure California town of Los Angeles. Her relics have been transferred from her namesake to the new Cathedral of Our Lady of the Angels.

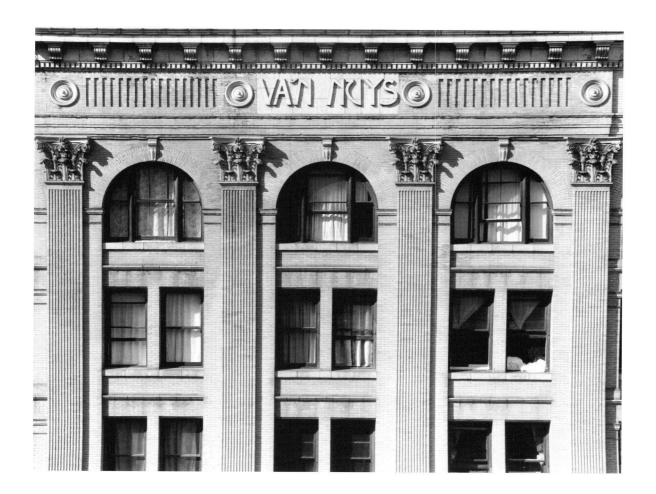

VAN NUYS HOTEL, W. FOURTH AND S. MAIN STREETS, 1896

Just before 2:00 p.m. on May 9, 1901, the Mermaid, a special touring car of the Los Angeles and Pacific Railroad, pulled up on Fourth Street below this sign to take President William McKinley, the first chief executive to visit L. A., to Sawtelle to address his fellow Civil War veterans at the Soldiers' Home.

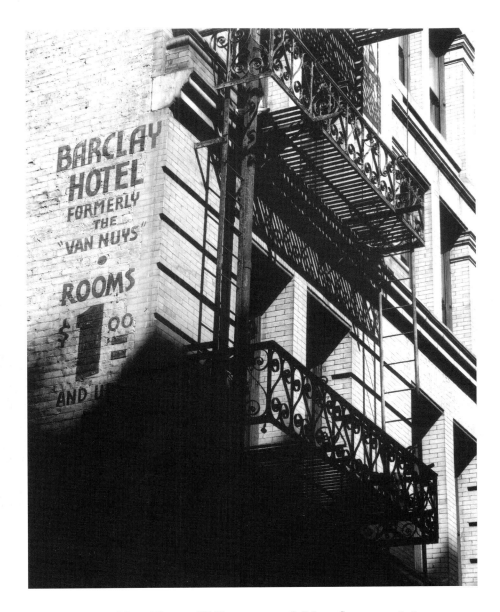

VAN NUYS HOTEL, W. FOURTH AND S. MAIN STREETS, 1896

The Barclay has a double room on the second floor where the separating wall has been removed, allowing it to be used for filming. Hollywood was one of the few industries that brought income to the Historic Core in the 1970s and 1980s.

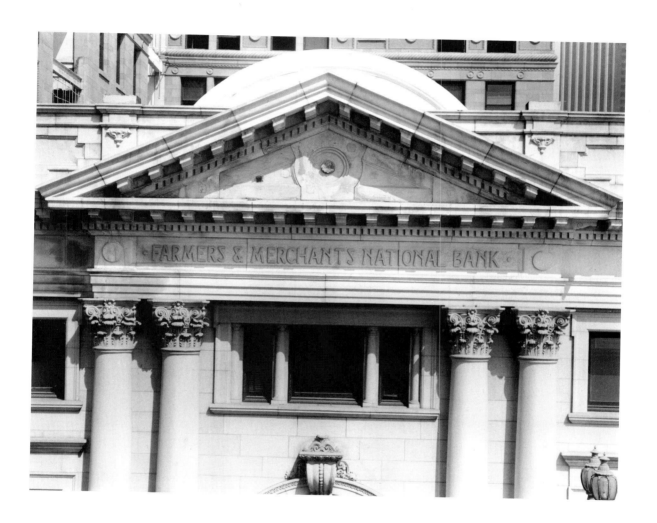

Farmers and Merchants Bank Building, W. Fourth and S. Main Streets, 1904

Isaias Hellman's financial genius helped keep Los Angeles from going broke in the bust following the boom of the 1880s. His Farmers and Merchants Bank was the strongest in the city, eventually being eclipsed by the Bank of America and Security First National. The building also gave its name to Tom Gilmore's Old Bank District.

ROSSLYN HOTEL, W. FIFTH AND S. MAIN STREETS, 1913

The ballroom is on the second floor of the original Rosslyn Hotel. A parking garage was added to the hotel to accommodate guests who were increasingly arriving in automobiles instead of by train.

DOWNTOWN IN DETAIL

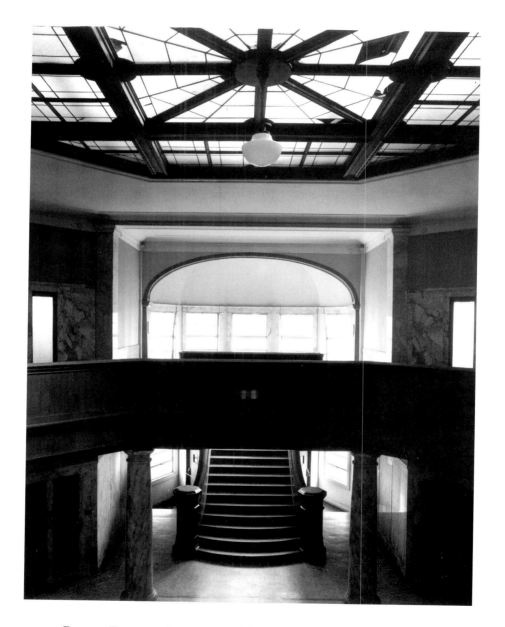

Pacific Electric Building, W. Sixth and S. Main Streets, 1905

This staircase leads to Henry Huntington's office and the original Jonathan Club. For decades, the Pacific Electric Building was the largest building in volume west of the Mississippi. It has become a loft.

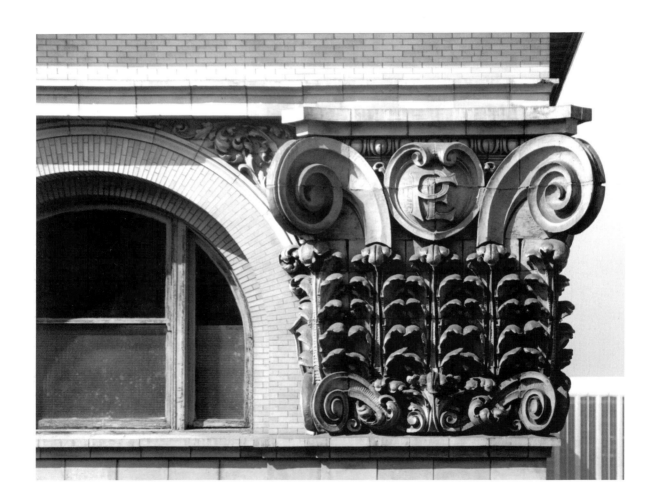

PACIFIC ELECTRIC BUILDING, W. SIXTH AND S. MAIN STREETS, 1905

This is the top-floor herald on the central depot of the largest interurban trolley system in the world. If only *Who Framed Roger Rabbit?* (1988) hadn't been a fantasy.

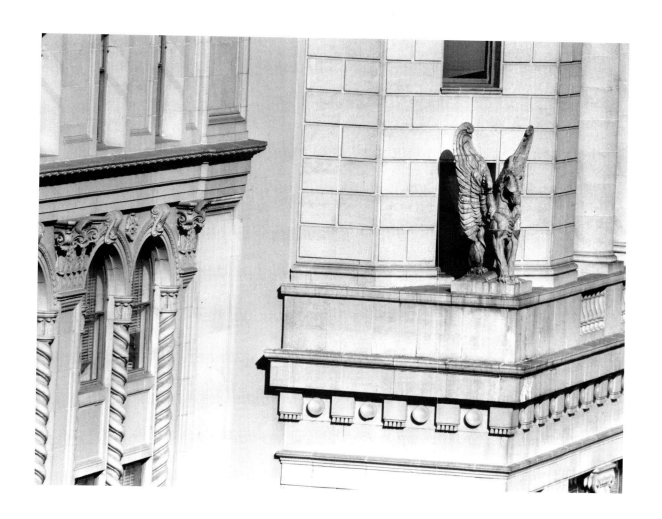

BOARD OF TRADE BUILDING, W. SEVENTH AND S. MAIN STREETS, 1927

Consider it "Spring Street adjacent"—part of the Financial District. The Pegasus was soon watching over the assets of the building's chief tenant: Bank of America. The building sported the first automated elevators on the Pacific Coast.

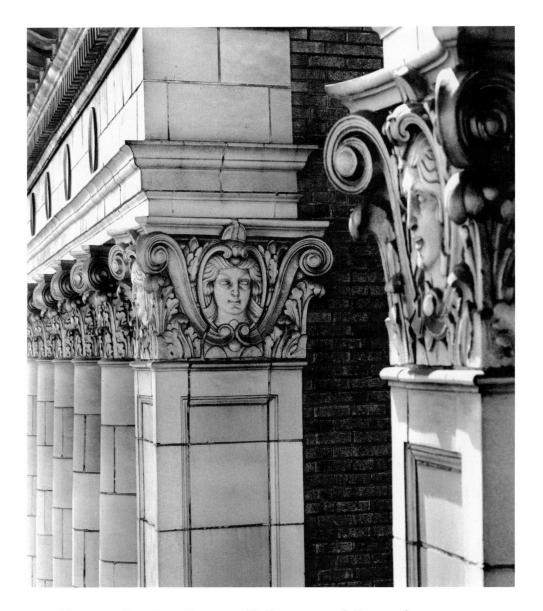

NATIONAL CITY BANK BUILDING, W. EIGHTH AND S. FLOWER STREETS, 1924

The female faces are just below the cornice, visible only from inside the building and the fire escape. In this loft-conversion building, the street level is being returned to its original design, reversing a 1950s modernization.

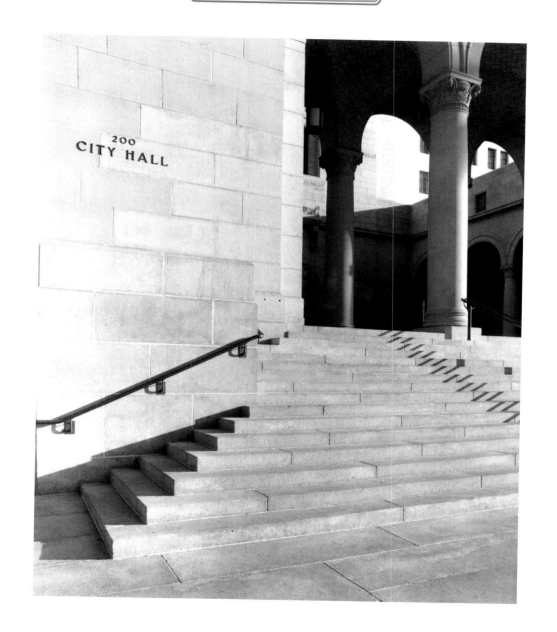

LOS ANGELES CITY HALL, 200 N. SPRING STREET, 1928

The stairs became known as the Victory Steps in 1945 when victory in Europe and victory in Japan were both celebrated there.

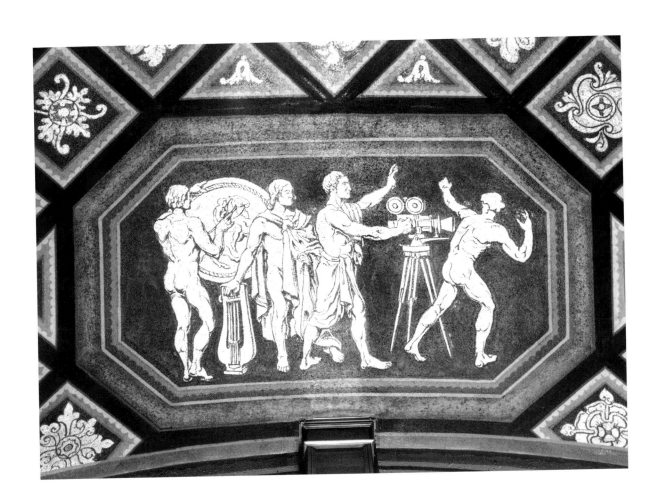

LOS ANGELES CITY HALL, 200 N. SPRING STREET, 1928

The ceiling above the elevators on the Spring Street side depicts what might have happened if Aristotle and the lads had discovered Los Angeles.

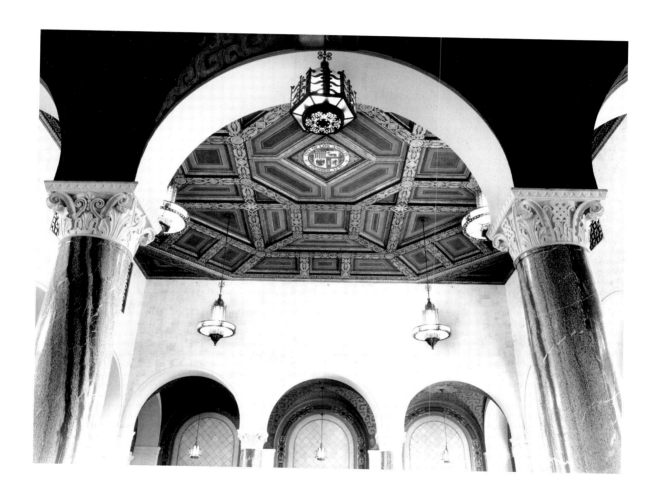

LOS ANGELES CITY HALL, 200 N. SPRING STREET, 1928

The coffered ceiling of the Board of Public Works Session Room sits to the north of the magnificent entrance Rotunda.

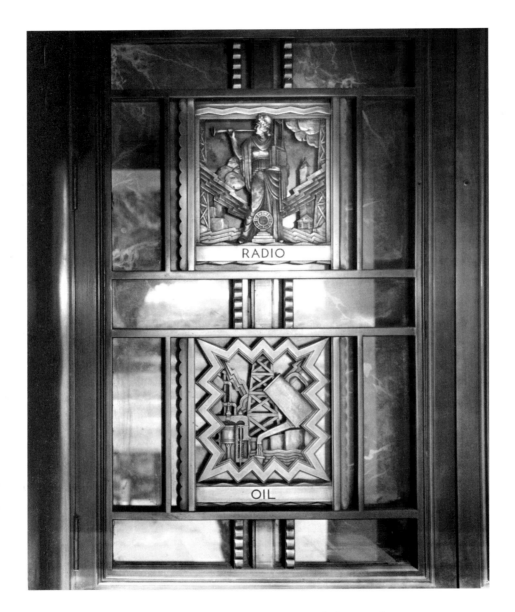

LOS ANGELES TIMES BUILDING, W. FIRST AND S. SPRING STREETS, 1935

This is one of a series of twelve bronze panels above the original entrance on First Street illustrating the various topics covered by the newspaper. Gordon Kaufmann's design for the Times Building won a gold medal at the 1937 Paris Exposition.

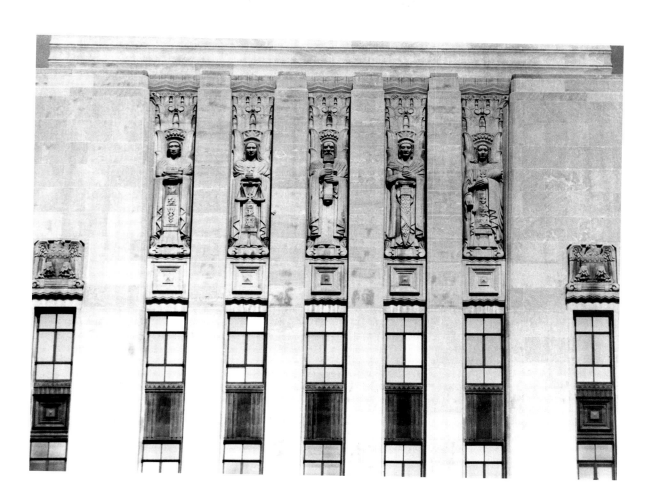

LOS ANGELES TIMES BUILDING ADDITION, W. FIRST AND S. SPRING STREETS, 1948

Sculptor Harry Donato created five bas-relief panels for architect Rowland Crawford's addition to the newspaper's headquarters, with the four female figures representing Culture, Justice, Faith and Progress.

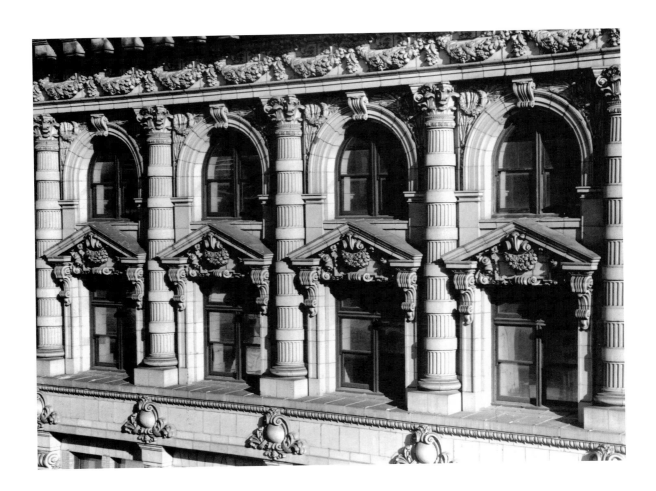

Braly Block / Continental Building, W. Fourth and S. Spring Streets, 1904

Los Angeles' first skyscraper was designed by Spring Street's main architect, John Parkinson. It set the style for the Height Limit Law that would soon follow, restricting the city's buildings to 150 feet in height.

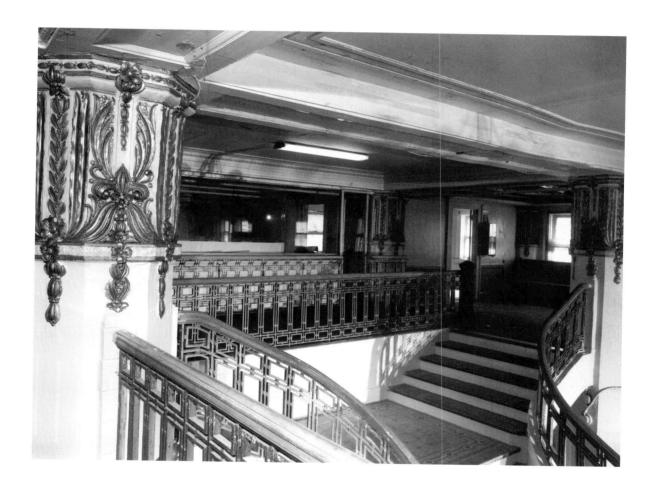

Stowell Hotel / El Dorado Hotel, 416 S. Spring Street, 1913

The stairway to the mezzanine level ascends from the ornate, Batchelder tile-filled lobby.

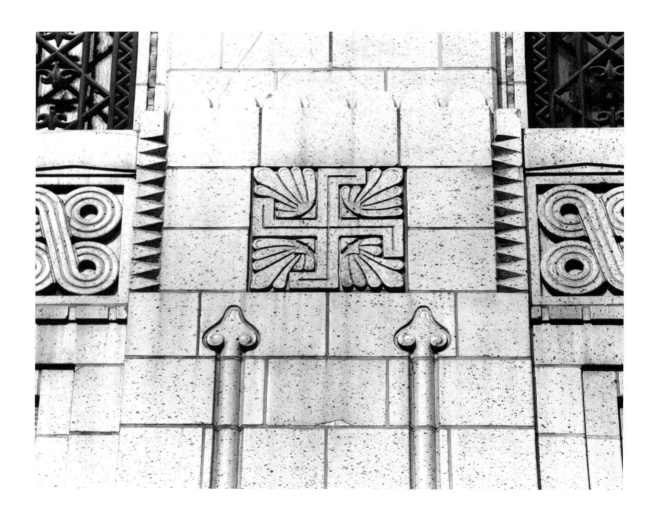

TITLE INSURANCE & TRUST COMPANY BUILDING, 433 S. SPRING STREET, 1928

The swastika is the single most cruelly usurped symbol in history. For millennia it stood for universal harmony, stability and balance, used by Hindus, Buddhists and Navajos. Now it conjures up thoughts of a regime of lunatics and the most horrific war in history.

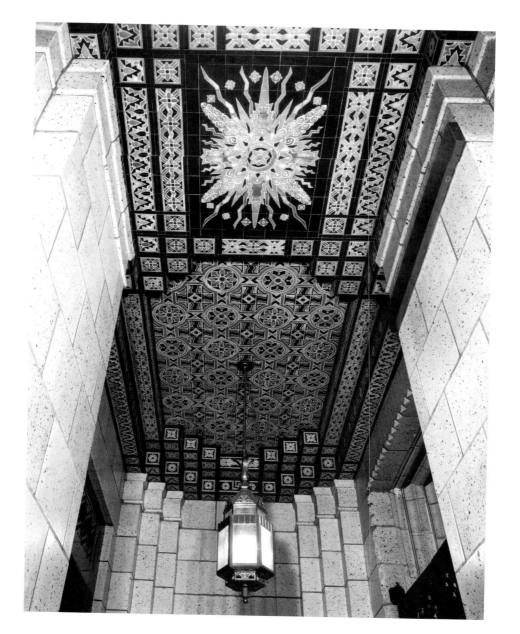

TITLE INSURANCE & TRUST COMPANY BUILDING, 433 S. SPRING STREET, 1928

This California Claycraft tile ceiling is in the vestibule on Spring Street.

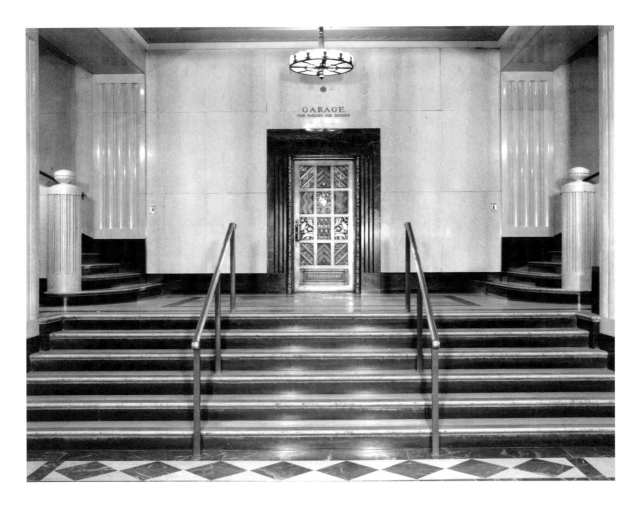

TITLE INSURANCE & TRUST COMPANY BUILDING, 433 S. SPRING STREET, 1928

At the rear of the lobby of the Title Insurance & Trust Company Building is what must be the most ornate door to a parking garage anywhere in Los Angeles. As autos proliferated in the 1920s, a downtown building with its own garage became highly desirable.

ALEXANDRIA HOTEL, W. FIFTH AND S. SPRING STREETS, 1906

Griffins watch over what was the premier downtown hotel. Charlie Chaplin had an office here, as did many other moguls, in the early days of the Southern California film industry. In 1919, President Woodrow Wilson spent the night here while on a national tour to promote the League of Nations to the American people.

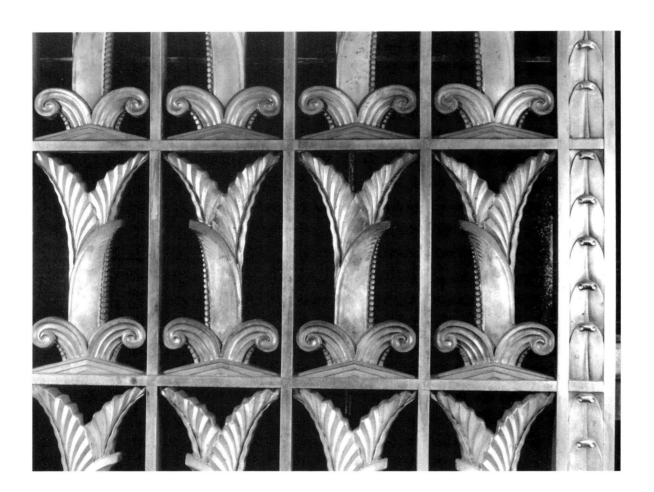

BANKS-HUNTLEY BUILDING, 630-634 S. SPRING STREET, 1930

The building was designed for stockbrokers Banks and Huntley by Parkinson and Parkinson in the architects' Deco period as its gate reflects. In the 1990s, the Mexican American Legal Defense and Educational Fund rehabilitated the building, creating offices for itself and other non-profit organizations.

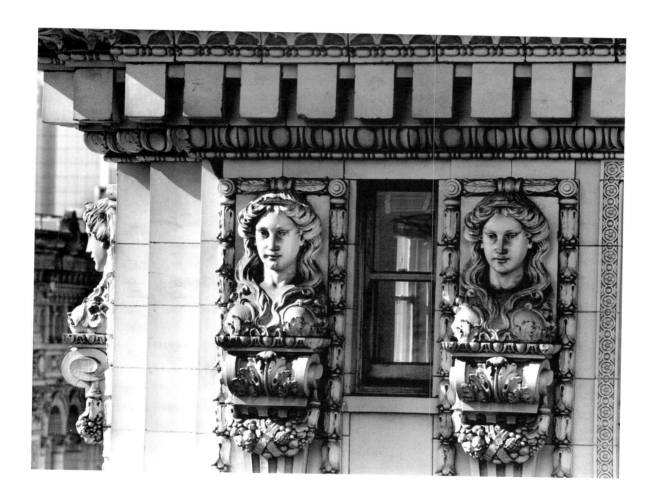

Los Angeles Trust and Savings Bank Building, W. Sixth and S. Spring Streets, 1910

The Spring Street ladies line the top of another John Parkinson building along its Sixth and Spring Streets' façades. Like so much downtown detail, the ladies are only visible from an opposite building.

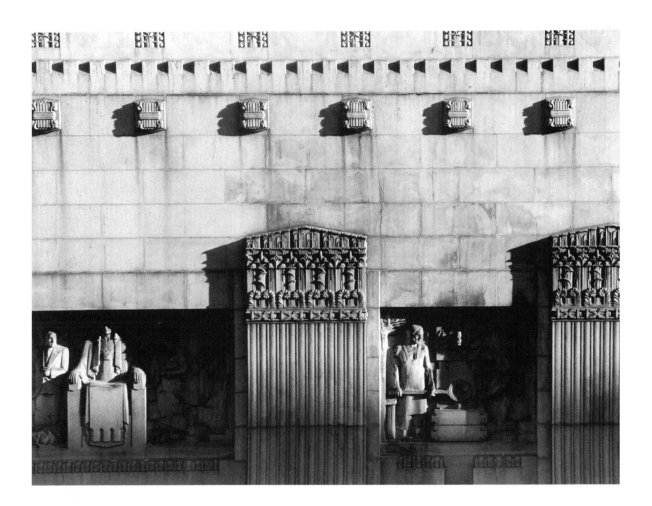

Los Angeles Stock Exchange Building, 618 S. Spring Street, 1930

The three Salvatore Scarpitta bas-relief panels on the façade of the Stock Exchange are meant to symbolize the three elements of capitalism: Production, Finance, and Research and Development. These are Finance and Production.

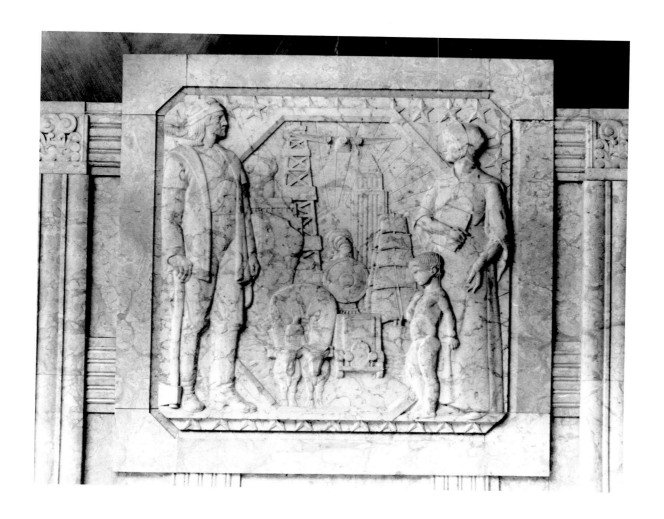

Los Angeles Stock Exchange Building, 618 S. Spring Street, 1930

The relief on the mantel above the fireplace in the boardroom of the Stock Exchange celebrates the history of Los Angeles. The building was the home of the Los Angeles (later Pacific Coast) Stock Exchange from 1931 to 1986.

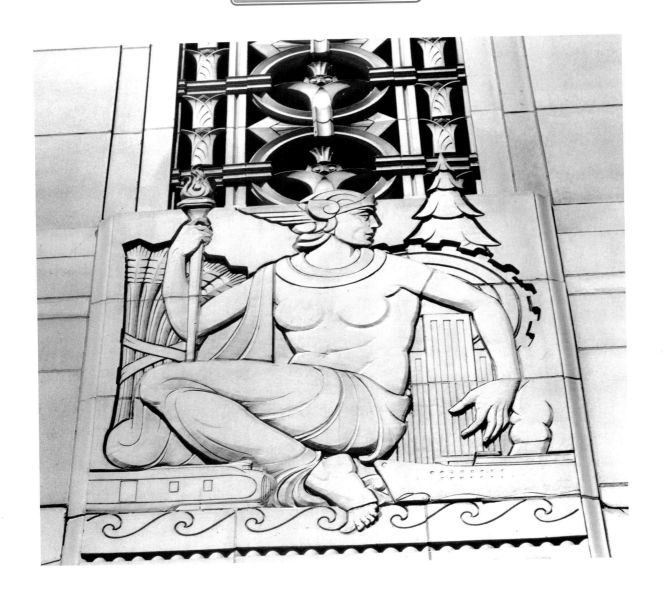

Union Oil Building / Bartlett Building, W. Seventh and S. Spring Streets, 1911

There were two major recladding eras for the Central Core: the streamlining of the 1930s and the "internationalizing" of the 1950s. Mercury, pictured here, became part of the Union Oil Building in that first era of modernization.

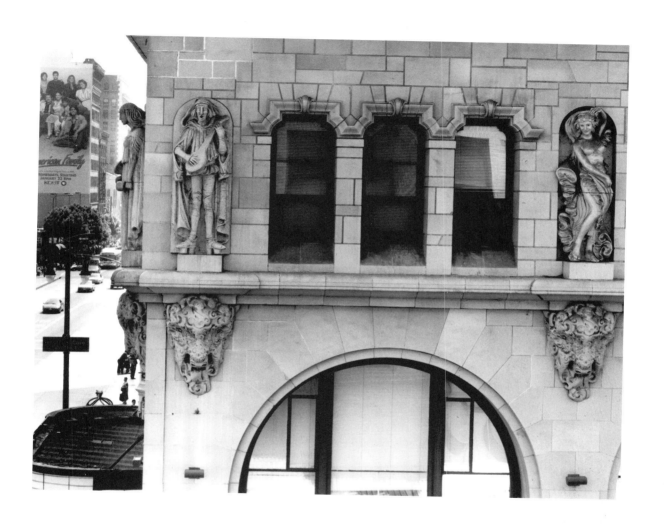

EDISON BUILDING / MILLION DOLLAR BUILDING, W. THIRD STREET AND S. BROADWAY, 1918

Sid Grauman's first downtown theater, the Million Dollar, occupies the ground floor where figures from the stage share exterior space with the West's greatest symbol, the buffalo. In the 1960s, the theater became the home of Mexican vaudeville in Los Angeles.

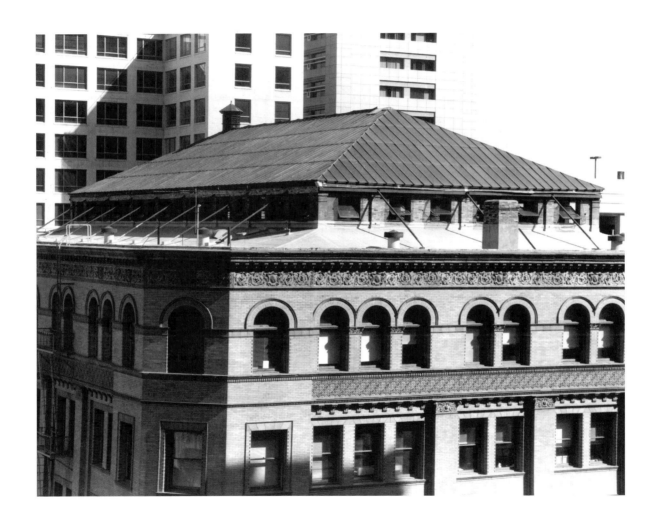

BRADBURY BUILDING, W. THIRD STREET AND S. BROADWAY, 1893

During World War II, a large curtain under the skylight of this masterpiece building was pushed open with long poles during the day and pushed closed at sunset in compliance with the city's mandatory blackout.

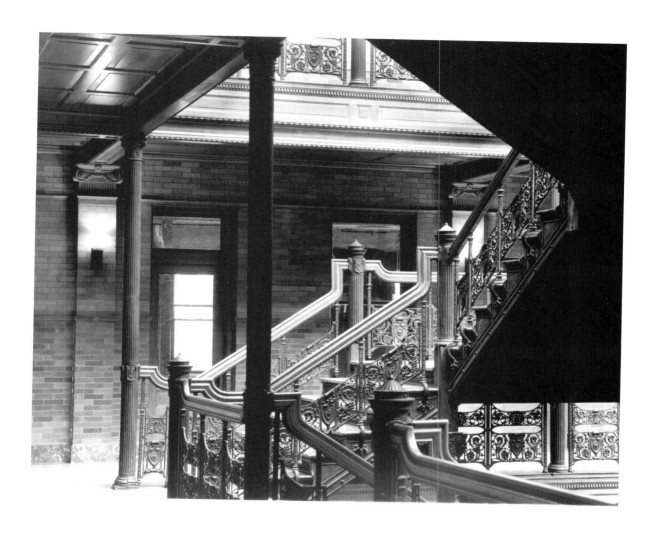

BRADBURY BUILDING, W. THIRD STREET AND S. BROADWAY, 1893

This interior stairway is in the atrium. The workings of the open-shaft elevator are on display. Stairs and balustrades are of American oak, Belgian marble, Mexican tile and French wrought iron that was originally displayed at the 1893 Chicago World's Fair.

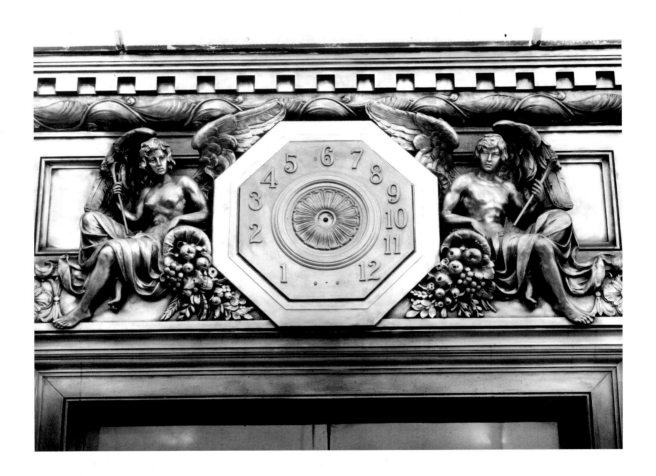

CHESTER WILLIAMS BUILDING, W. FIFTH STREET AND S. BROADWAY, 1926

Angels bless the elevator in the Fifth Street lobby.

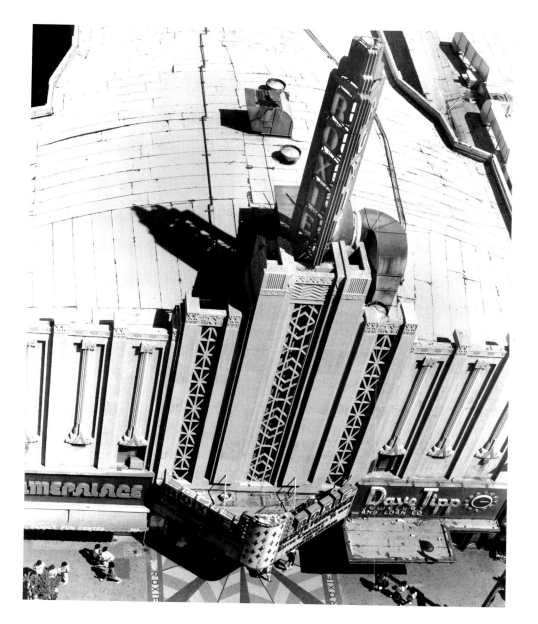

ROXIE THEATRE, 518 S. BROADWAY, 1932

The last theater built in the Broadway district, the Roxie replaced the brightest façade on Broadway: the demolished Quinn's Superba. Now it is reduced to a series of storefronts.

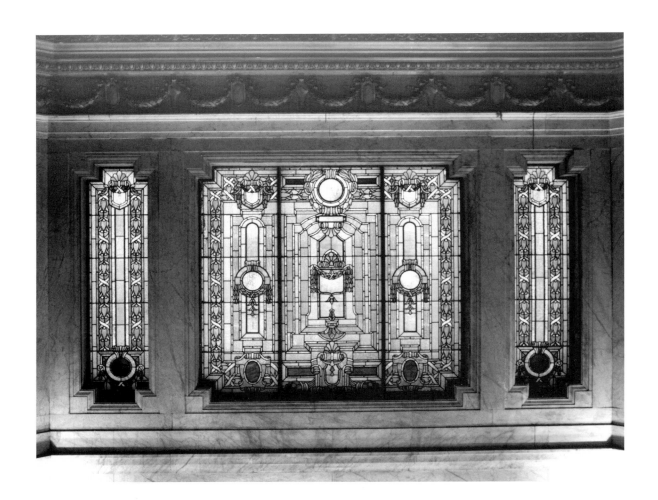

W.P. Story Building, W. Sixth Street and S. Broadway, 1908

Stained glass is fairly rare downtown. The Story Building's stained glass is in the stairway to the second floor. Two other examples that stand out: a large window overlooking Broadway at the Tower Theatre and a small one off the lobby in the Van Nuys Building on Spring Street.

W.P. STORY BUILDING, W. SIXTH STREET AND S. BROADWAY, 1908

The penthouse home of Mr. and Mrs. Walter P. Story atop his building is in fact a small, two-bedroom house. Gardens and fountains once surrounded it. After service in the U.S. Army during World War I, Story went on to become a general in the California National Guard and command operations in the Long Beach area following the earthquake of 1933.

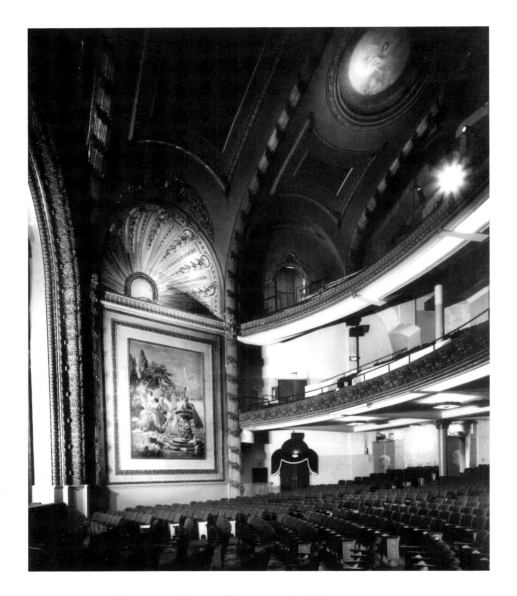

ORPHEUM / PALACE THEATRE, 630 S. BROADWAY, 1911

The Orpheum chain of theaters staged the most vaudeville productions in the West. This was the third of four L.A. houses the chain operated. When it was converted from a vaudeville house to a movie theater, the sightlines for a movie house were hopeless, so the box seats were replaced by Anthony Heinsbergen's murals. During World War II it became a newsreel theater.

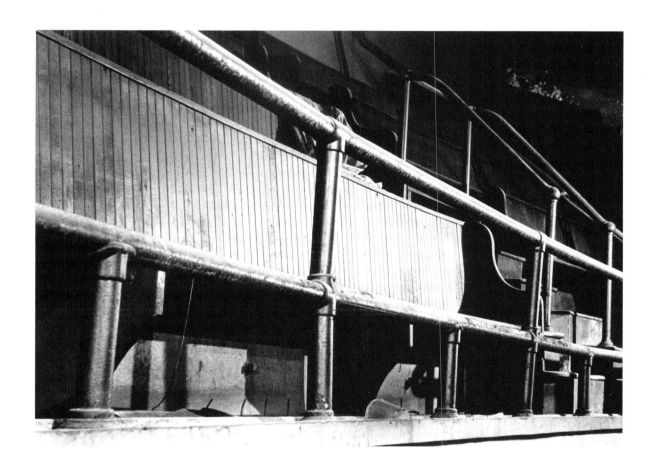

ORPHEUM / PALACE THEATRE, 630 S. BROADWAY, 1911

The higher of the two balconies in the Orpheum / Palace was called the "colored balcony" and could only be entered from the alley behind the theater, not through the lobby. Jim Crow prowled the streets even in twentieth-century Los Angeles.

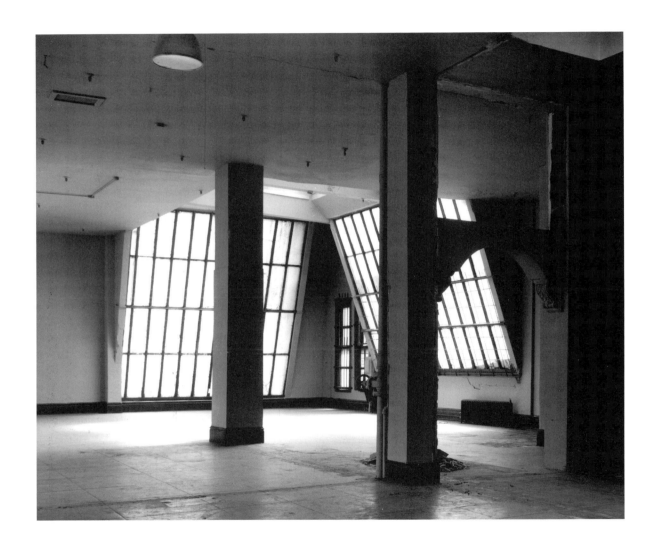

ORPHEUM / PALACE THEATRE, 630 S. BROADWAY, 1911

Reached by what must be one of the last manual elevators downtown, the fourth floor was originally a photographer's studio operated by Fred Hartsook. He was one of those early Southland photographers who benefited greatly when the film industry blew into town and hundreds of actors needed portraits. Skylights were necessary for photo studios in those early days of slow film and minimum electrical wattage.

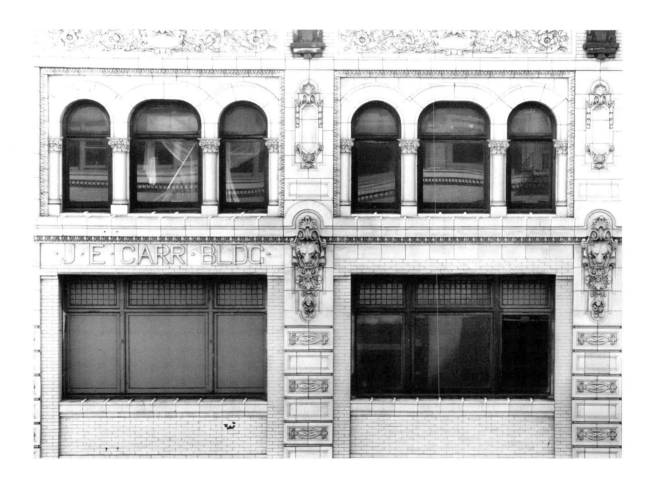

J.E. CARR BUILDING, 644 S. BROADWAY, 1910

This typical mid-block Beaux Arts office building housed the Harris and Frank and the Bond clothing companies on the ground floor. The offices above are long gone, as is the lobby entrance to them. A particularly ghastly metal mesh covers the lower façade, as is the case with its neighbor, Clifton's Cafeteria.

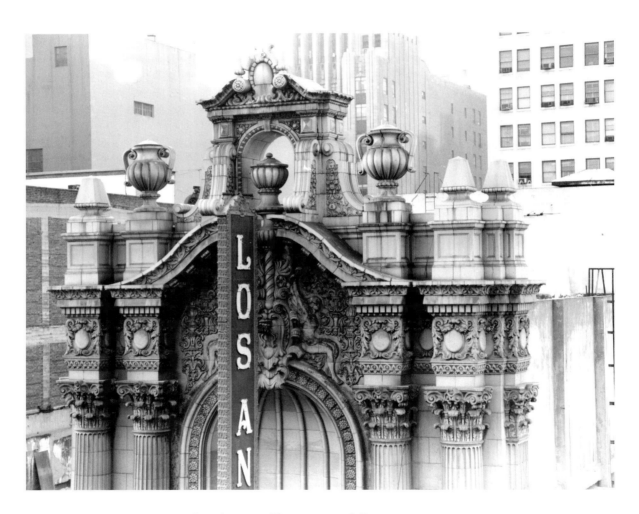

LOS ANGELES THEATRE, 615 S. BROADWAY, 1931

The most glorious of the Broadway palaces was designed by S. Charles Lee and opened during the nadir of the Depression with the premiere of Charlie Chaplin's *City Lights* (1931). It soon closed, to reopen as a second-run house.

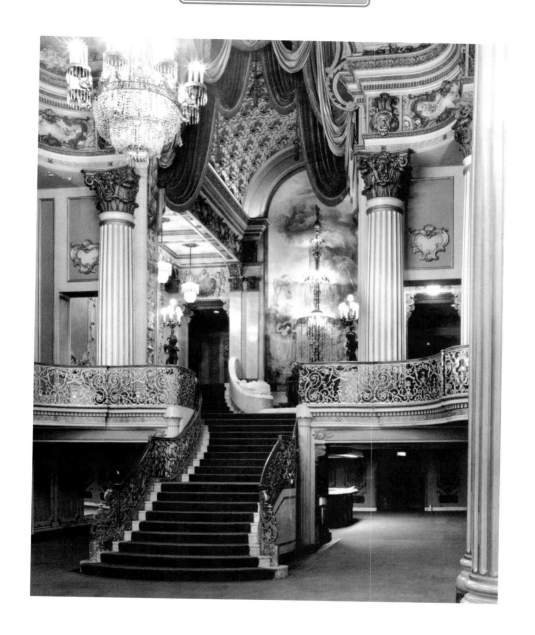

LOS ANGELES THEATRE, 615 S. BROADWAY, 1931

The theater lobby was inspired by the Hall of Mirrors in the Palace of Versailles in Paris. It has been magnificently restored and is used for special events.

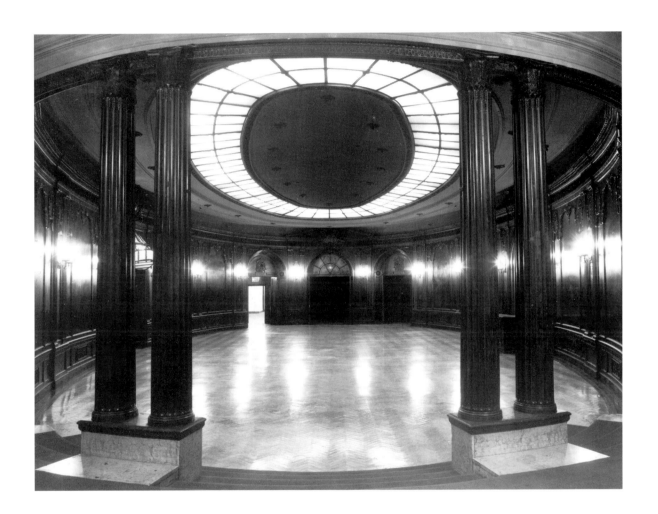

LOS ANGELES THEATRE, 615 S. BROADWAY, 1931

The most ornate women's restroom in Los Angeles is next to the ballroom beneath the theater. The ballroom featured a screen and speakers to view the movie screening in the theater. To the rear was a kitchen.

CLIFTON'S BROOKDALE CAFETERIA, 648 S. BROADWAY, 1935

Each of Clifford Clinton's three downtown cafeterias had a meditation room. The only cafeteria remaining is in Clifton's homage to the California redwood country on the site of the former Boos Brothers Cafeteria on Broadway. Clinton gave away tens of thousands of meals during the Great Depression to people who could not afford to pay. He said, "We pray our humble service be measured not by gold but by the Golden Rule." And he meant it.

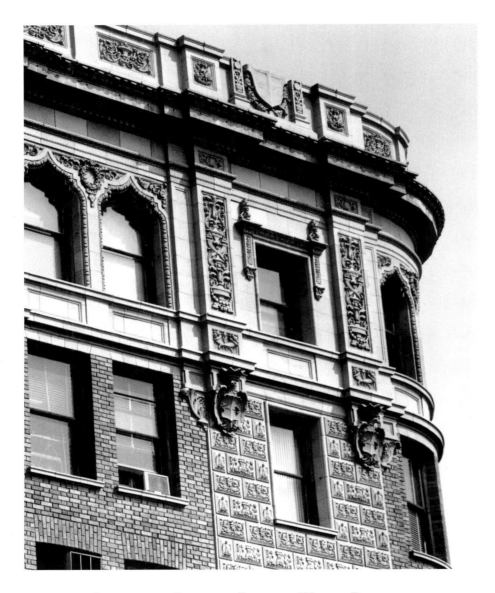

**SEVENTH AND BROADWAY BUILDING / UNITED BUILDING,
W. SEVENTH STREET AND S. BROADWAY, 1921**

The State Theatre is on the ground floor. It was formerly part of the Loew's chain and all the first-run MGM features appeared there. From the 1920s into the 1950s, Seventh and Broadway was the busiest intersection in Los Angeles.

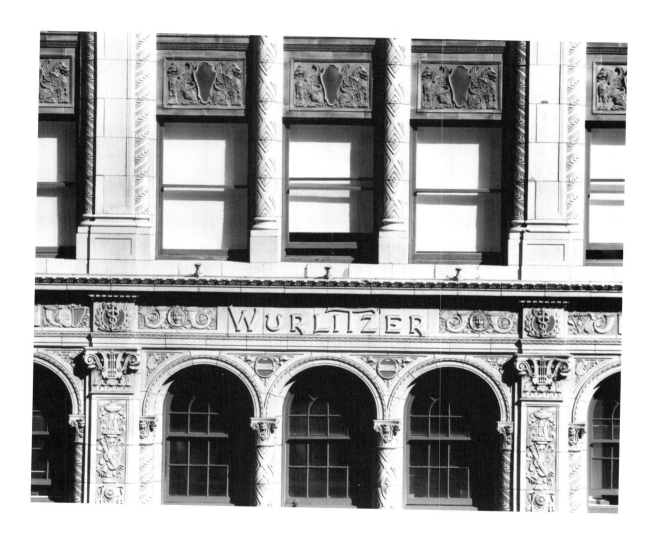

WURLITZER BUILDING, 818 S. BROADWAY, 1924

The Mighty Wurlitzer was the king of theater organs during the silent era. Practically every sound under the sun could be urged out of it, and the instrument made the perfect accompaniment for silent movies. A fine example is still in use at the Orpheum Theater two buildings south.

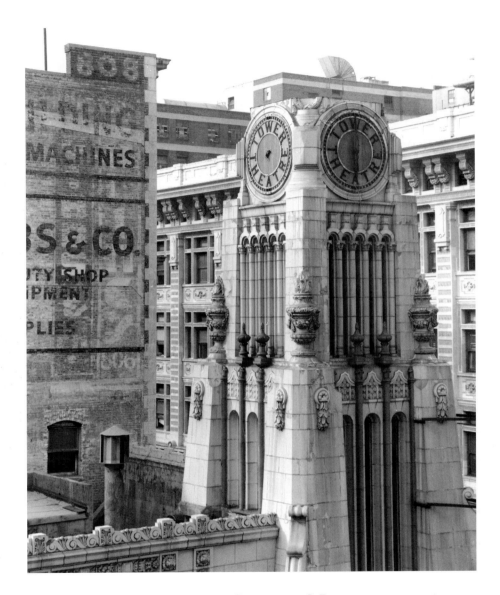

TOWER THEATRE, W. EIGHTH STREET AND S. BROADWAY, 1925-1926

The first major theater designed by S. Charles Lee was the first downtown theater built for talkies. Lee went on to create the Fox Wilshire, the Fox Florence, the Los Angeles, the Bruin, the Academy and the Picwood Theatres, among many others. The top of the clock tower was removed due to damage from the 1971 Sylmar earthquake.

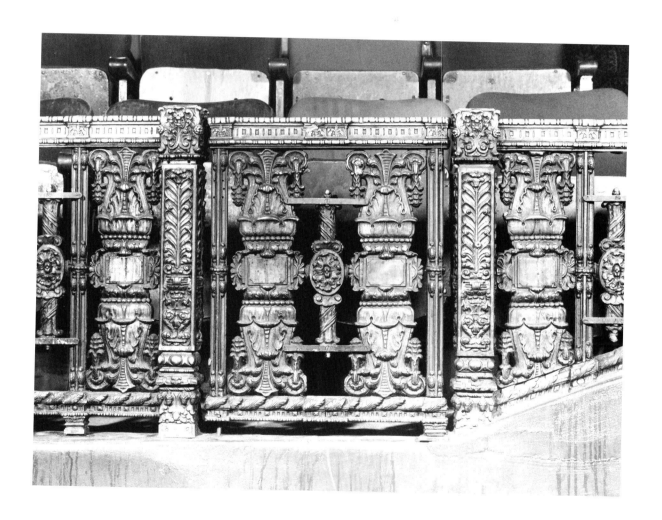

TOWER THEATRE, W. EIGHTH STREET AND S. BROADWAY, 1925-1926

The seats on the auditorium floor were removed years ago when the Tower was going to be converted into a night club, but the balcony in the theater auditorium is still intact.

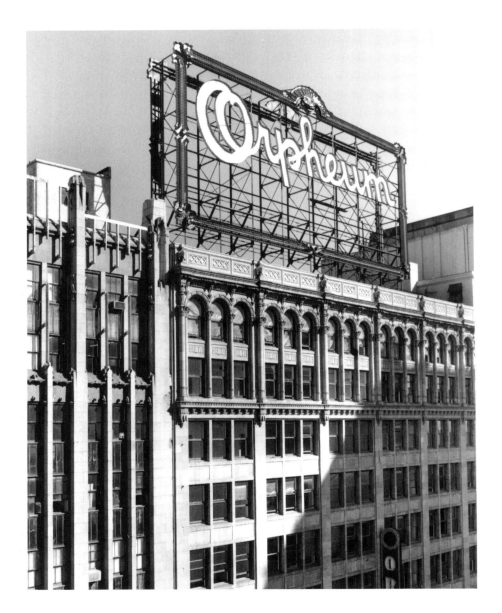

ORPHEUM BUILDING, 842 S. BROADWAY, 1926

When the heroic roof sign of the Orpheum was rebuilt in 2000, only the lettering on the Broadway side was re-created; originally it displayed the theater name on both sides. The neon "Vaudeville" that once appeared on the bottom left was not included on the new sign.

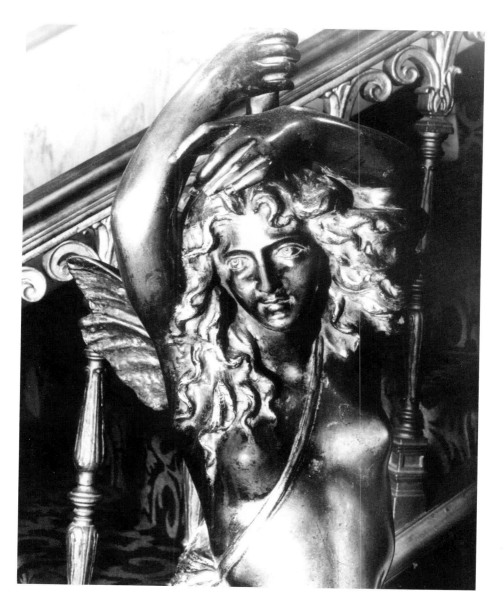

ORPHEUM BUILDING, 842 S. BROADWAY, 1926

Helen the Light Lady is illuminating the east end of the lobby of the Orpheum Theatre. If you spend enough time around Helen, you will find she has magical properties. Step right up and introduce yourself and see if Helen doesn't raise your spirits.

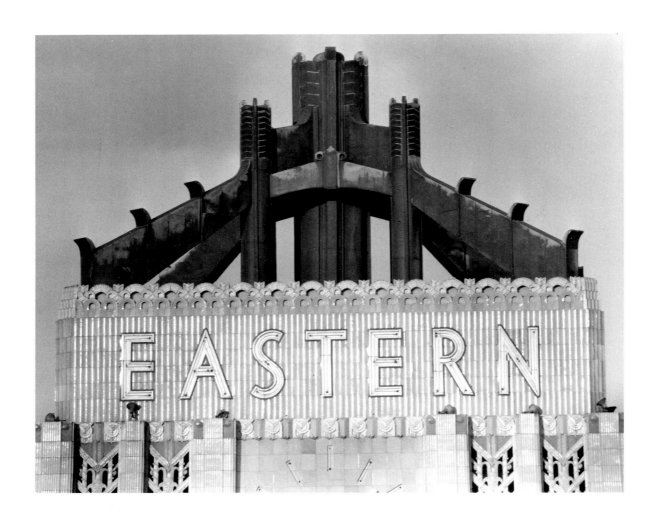

EASTERN COLUMBIA BUILDING, W. NINTH STREET AND S. BROADWAY, 1929

Claud Beelman's masterpiece for the Eastern Columbia Outfitting Company is clad in aquamarine-colored, glazed terra cotta. The anti-Jurassic-monster-shield sculpture that decorates the building's smokestack circumvents the 150-foot height limit since it advertises the building.

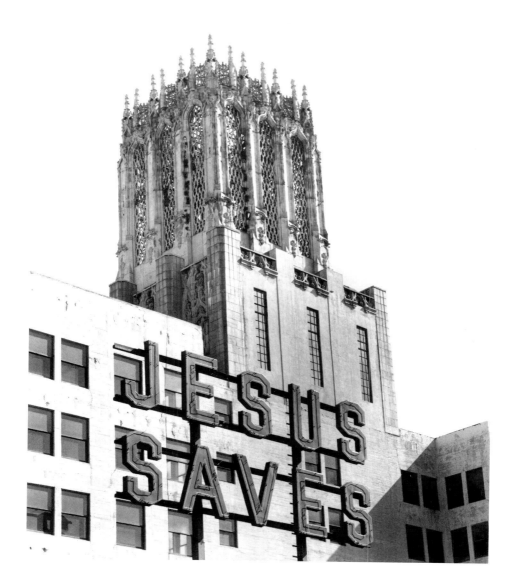

TEXACO BUILDING, 931 S. BROADWAY, 1927

The ornate tower covers the building's smokestack. The "Jesus Saves" neon sign was originally located on the roof of the Church of the Open Door located on Hope Street. Dr. Gene Scott tried to buy the building to keep it from demolition. He failed in that, but saved the sign. He bought the United Artists Theatre to use as his church, beautifully restored it and placed the "Jesus Saves" sign behind it.

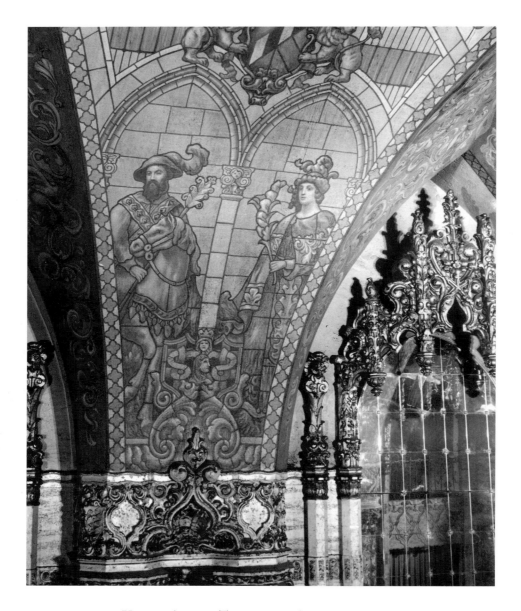

UNITED ARTISTS THEATRE, 933 S. BROADWAY, 1927

The medieval motif of Anthony Heinsbergen's murals nicely complements Dr. Gene Scott's collection of Bibles on display throughout the lobby. Current church elders claim the collection is second in size only to the holdings of the Vatican.

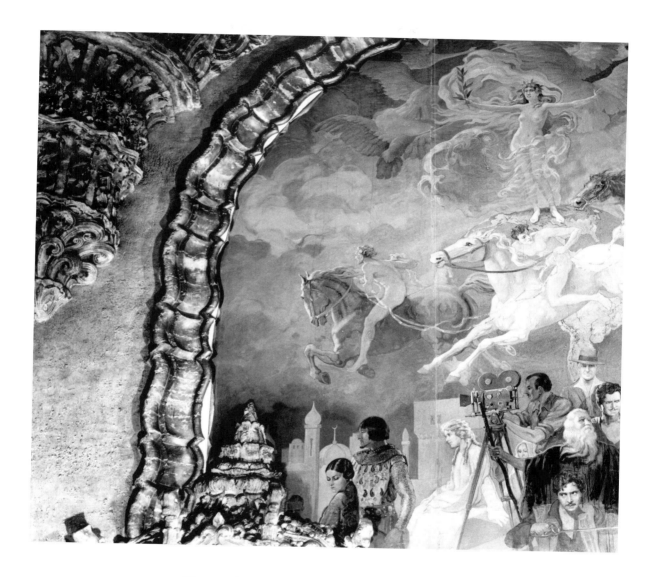

UNITED ARTISTS THEATRE, 933 S. BROADWAY, 1927

Mary Pickford, Douglas Fairbanks, Charlie Chaplin and D.W. Griffith formed United Artists in 1919 as a way for themselves and other independent producers to release and control their films. United Artists did not have its own chain of theaters (as did MGM, Warner Brothers, RKO, Fox and Paramount), but wanted a flagship theater and built it on Broadway, complete with a mural starring themselves.

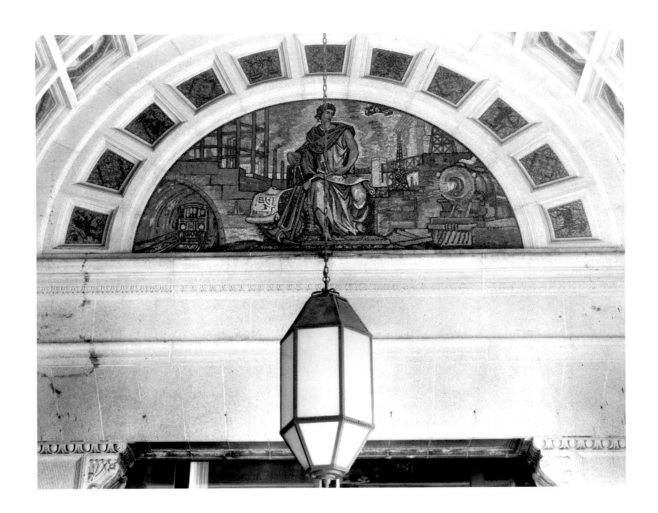

SUBWAY TERMINAL BUILDING, 417 S. HILL STREET, 1926

This mosaic is above the entrance to the Hollywood Subway Station beneath the Terminal Building. The purpose of the mile-long subway was to alleviate traffic on downtown streets. The rail line emerged at the Toluca Yards on Glendale Boulevard.

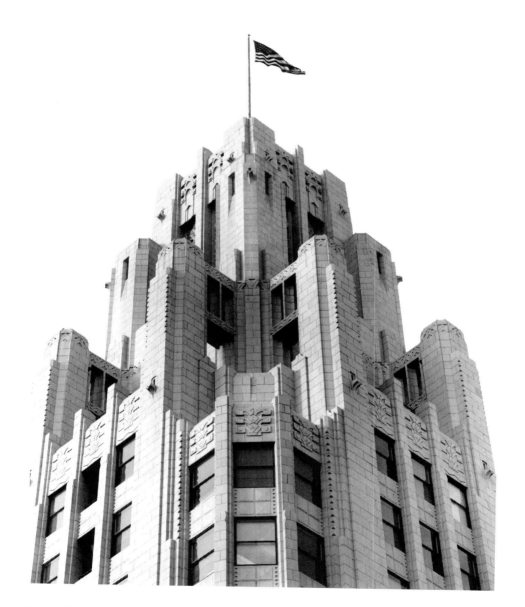

TITLE GUARANTEE & TRUST COMPANY BUILDING, W. FIFTH AND S. HILL STREETS, 1931

This John and Donald Parkinson building blends Gothic and Deco styles. The setback style came out of New York in 1916 in an effort to allow some sunlight onto the street. The buildings in Los Angeles were too short for the setback to make much difference, but it still took hold.

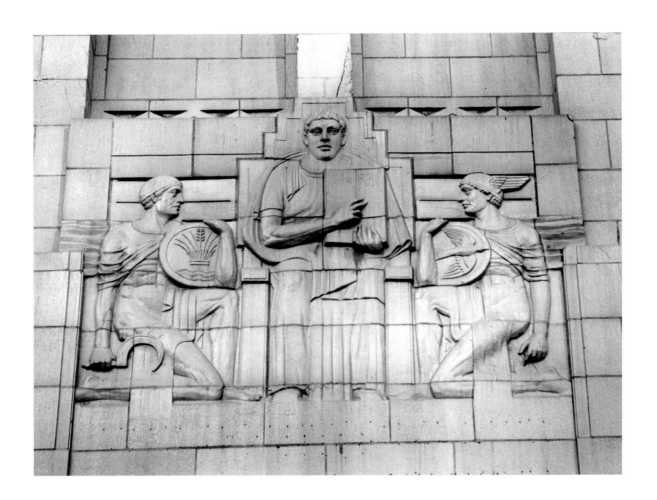

TITLE GUARANTEE & TRUST COMPANY BUILDING, W. FIFTH AND S. HILL STREETS, 1931

The bas-relief is above the Fifth Street entrance. The building now stands alone on its corner—the National Bank of Commerce to its north and the Philharmonic Auditorium to its west were both demolished.

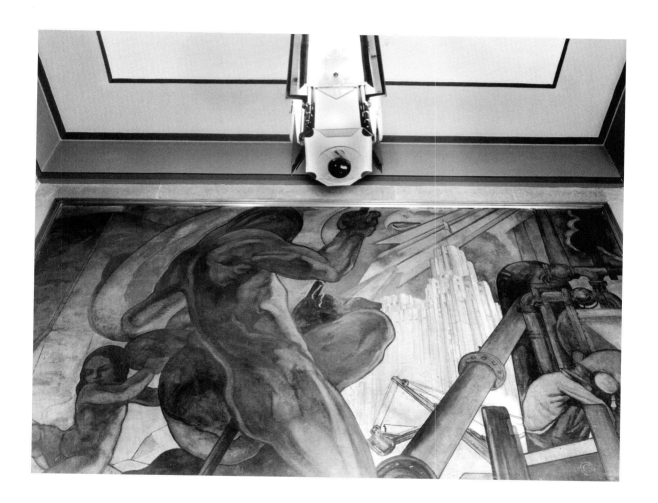

TITLE GUARANTEE & TRUST COMPANY BUILDING, W. FIFTH AND S. HILL STREETS, 1931

Muralist Hugo Ballin portrayed the power and strength of modern Los Angeles. Ballin came to the city to work for Samuel Goldwyn as an art director, then left film to go back to fine art after the talkies came in. He created some of the finest murals in Southern California, including those inside Wilshire Boulevard Temple and Griffith Observatory.

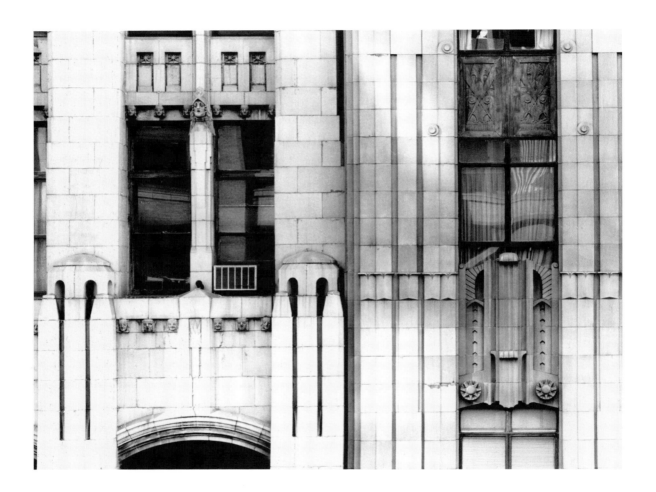

London Clothing / Wholesale Jewelry Mart, 635 S. Hill Street, 1925
Sun Realty Building / Los Angeles Jewelry Center, 629 S. Hill Street, 1930

These two different approaches to architectural decoration by Claud Beelman are joined at the hip: Gothic tracing and gargoyles on the left next to Deco-turquoise terra cotta piers and metal spandrels on the right. The two buildings are now part of Hill Street's jewelry district.

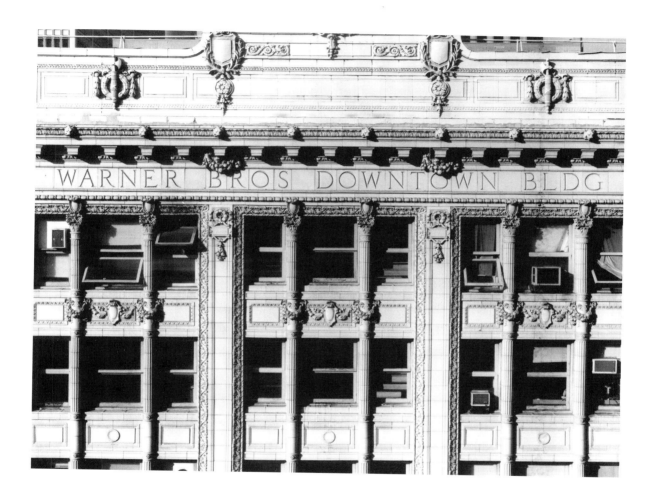

Pantages Theatre / Warner Brothers Downtown Building,
W. Seventh and S. Hill Streets, 1920

Alexander Pantages built his Los Angeles headquarters in 1920. In 1929, he was accused of raping a young woman in one of the building's closets. Although he was finally acquitted, he was financially ruined, and soon had to sell his theaters and holdings. The Hill Street building went to Warner Brothers, his Hollywood Boulevard theater to RKO.

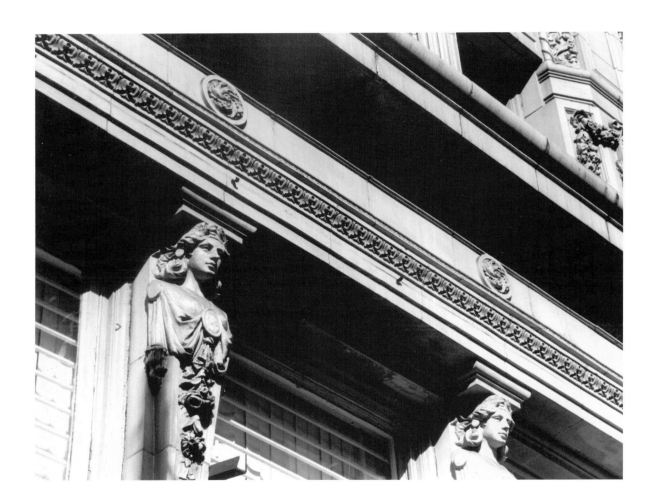

Pantages Theatre / Warner Brothers Downtown Building,
W. Seventh and S. Hill Streets, 1920

The female figures are just above the ground level, now watching over the comings and goings of jewelry buyers instead of theatergoers.

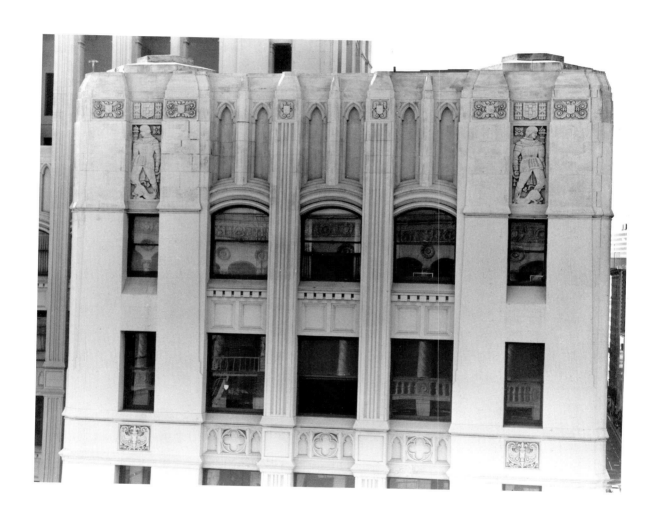

FOREMAN & CLARK BUILDING, W. SEVENTH AND S. HILL STREETS, 1928

Foreman & Clark was a major clothing store that, like the department stores, started in Downtown and later opened branch stores in the suburbs. The building has joined its cross-street neighbor, the Warner Brothers Theatre, as part of the downtown jewelry district.

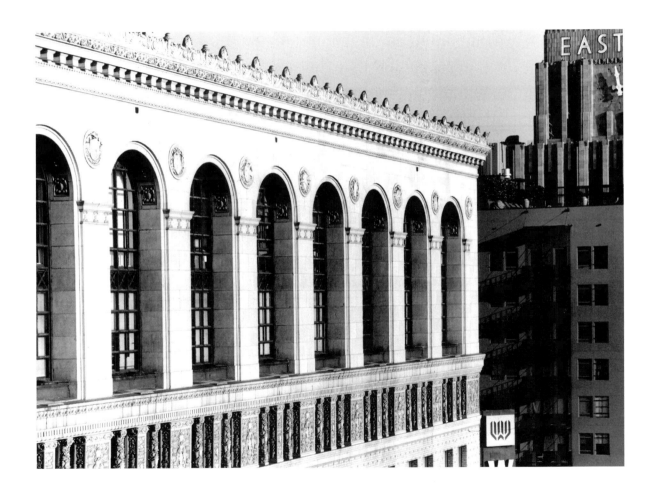

COAST FEDERAL SAVINGS BUILDING, W. NINTH AND S. HILL STREETS, 1926

Anyone who grew up watching television in Los Angeles in the late 1950s and early 1960s is condemned to forever have the image of a rabbit trying to put a coin in a bank that looks like the Coast Federal Savings Building and the Coast jingle rattling around in their head: "Coast Federal saves you more, Ninth and Hill on the ground floor. Open your savings account at Coast, Coast Federal Savings."

82

MAYAN THEATRE, 1040 S. HILL STREET, 1927

The Mayan has had a varied career. It formed a legitimate theater district with the Belasco next door when it first opened; soon it was wired for sound and turned into a movie house. After the war, it became a grind house, then a Spanish-language movie house in the 1950s. Adult-film producer Carlos Tobalina bought it in the 1970s, painted the previously plain Mayan figures on the outside and began showing X-rated features. In 1990, it became a nightclub.

BILTMORE HOTEL, W. FIFTH AND S. OLIVE STREETS, 1923

The Biltmore succeeded the Alexandria as the top downtown hotel and did righteous battle with the Ambassador in the far reaches of Wilshire for the title of leading hotel in the city. This grand entrance off Olive has been replaced by a protected motor entrance, reached from Fifth Street, no longer under the watchful eyes of Balboa and Columbus.

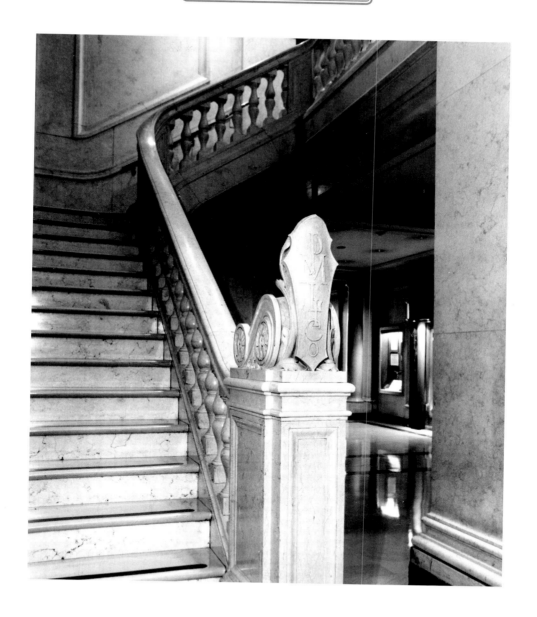

PACIFIC MUTUAL BUILDING, W. SIXTH AND S. OLIVE STREETS, 1922

L.A.'s premier insurance company kept expanding. The twelve-floor new building is joined to the six-story 1912 original, which was completely reclad in 1937 to make it look Moderne. Pacific Mutual is gone, and the building is now a rehabilitated office complex called the Pacific Center.

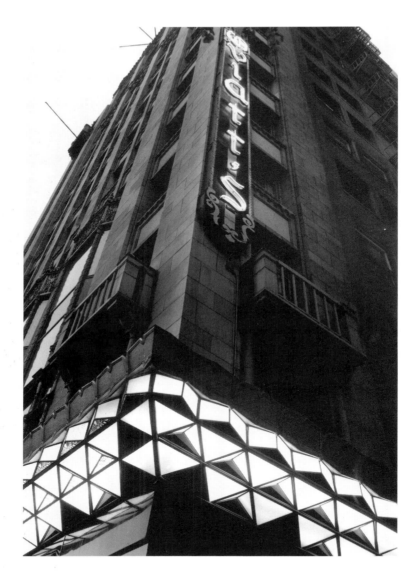

Oviatt Building, 617 S. Olive Street, 1928

James Oviatt attended the 1925 Paris *Exposition Internationale des Arts Decoratifs* that gave Art Deco its name and inspired him to have the interior of his building redesigned. He also saw French designer Rene Lalique's glass and George Claude's neon signs. Although America's first neon sign was atop Earl C. Anthony's Packard dealership at Seventh and Flower in 1926, this blade sign on the north elevation of the Oviatt Building complemented the building's Lalique accents.

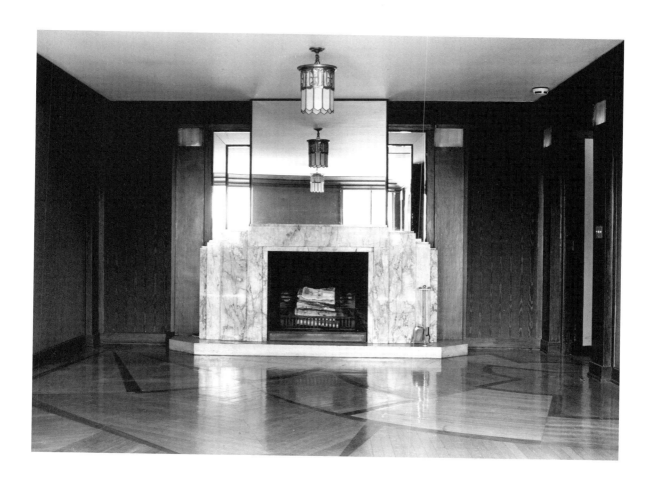

OVIATT BUILDING, 617 S. OLIVE STREET, 1928

Oviatt built a Deco-masterpiece penthouse on top of his building. In 1945, he noticed a new saleswoman in the store named Mary Richards: They soon wed and lived in the most elegant penthouse in downtown Los Angeles.

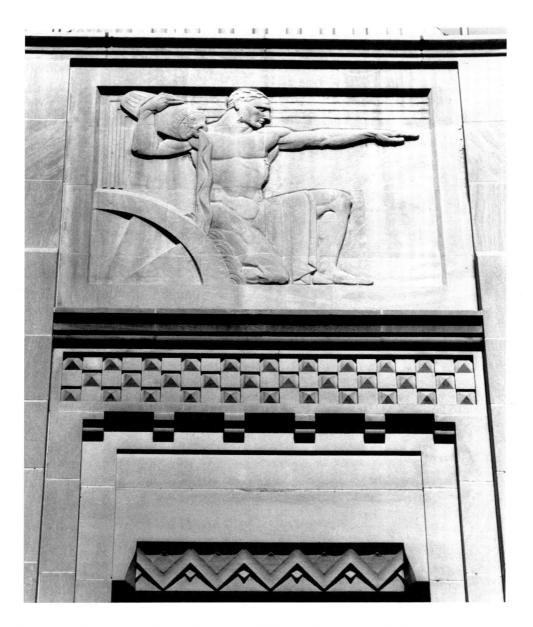

SOUTHERN CALIFORNIA EDISON BUILDING, W. FIFTH STREET AND S. GRAND AVENUE, 1931

Merrell Gage created the terra cotta relief panels representing Energy, Light and Power over the monumental corner entrance of the Edison Building. This is Energy.

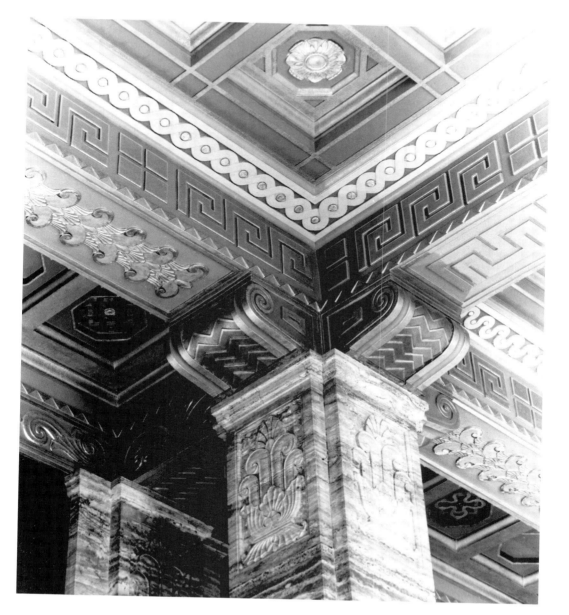

Southern California Edison Building, W. Fifth Street and S. Grand Avenue, 1931

Art Deco motifs take over the ceilings as well as the walls and floors. Also of note is Hugo Ballin's *Apotheosis of Power* mural on the west wall.

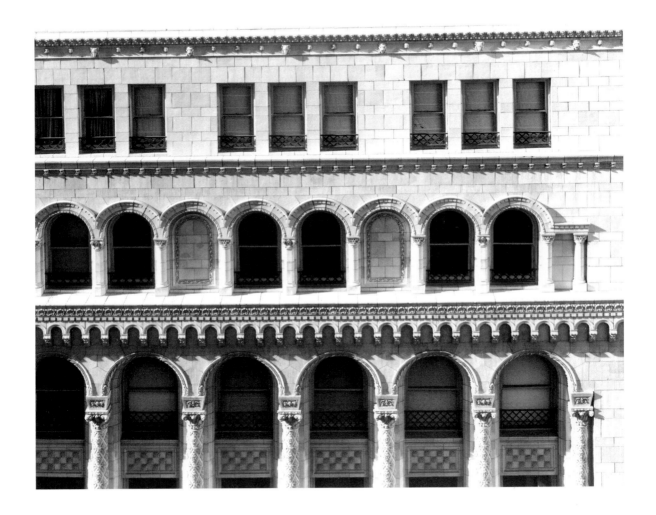

EDWARDS, WILDEY AND DIXON BUILDING, W. SIXTH STREET AND S. GRAND AVENUE, 1924

This classic downtown office building has been successfully rehabilitated into lofts, due in part to its address in the western section of Downtown.

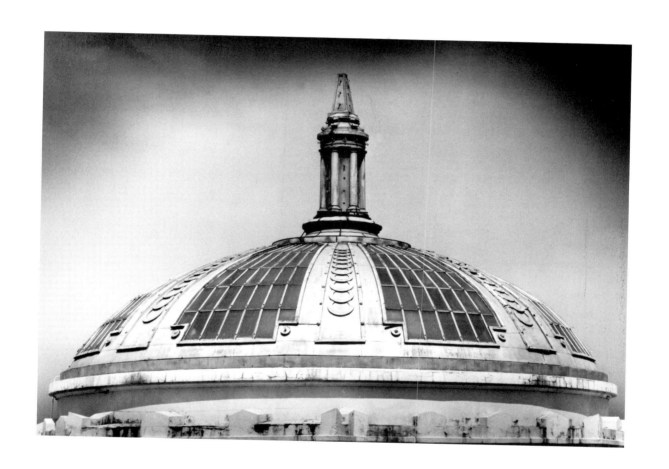

Embassy Auditorium and Hotel, W. Ninth Street and S. Grand Avenue, 1914

The domed penthouse is on the roof of the building. The great Frank Wiggins was the Chamber of Commerce leader who was the key to the promotional campaign that built Los Angeles in the early twentieth century. He lay in state at the Embassy when he died in 1924, and thousands of his fellow Angelenos came to pay their respects.

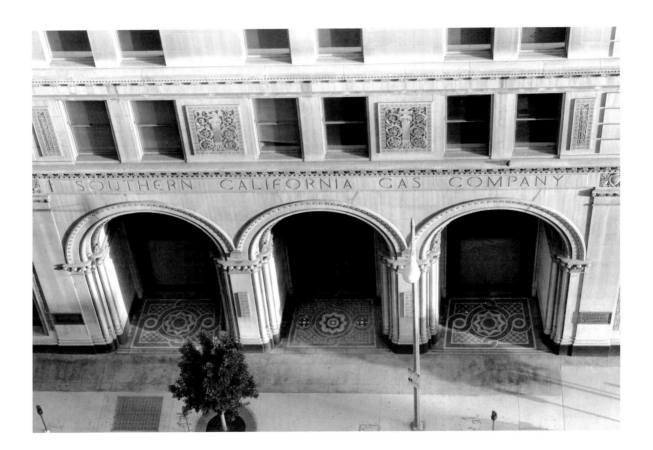

SOUTHERN CALIFORNIA GAS COMPANY BUILDING, W. EIGHTH AND S. FLOWER STREETS, 1926

People who want to live in this loft development have architectural choice. Southern California Gas built the original Beaux Arts structure in 1926 and followed with a streamlined addition on the south end in 1940, then an International-style expansion to the north in 1958. All three buildings are interconnected, forming a unified complex.

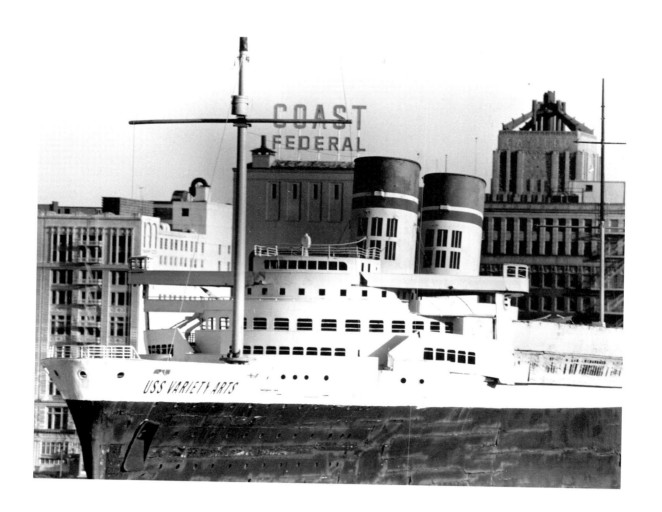

Friday Morning Club / Variety Arts Center, 940 S. Figueroa, 1922

The Friday Morning Club was originally a women's club competing with the neighbor men's business club bastions: the Jonathan Club and the California Club. Milt Larson, of Magic Castle fame, owned the Variety Arts Center in the 1980s. In the top-floor restaurant, he planned to hang autographed concrete blocks (which formerly graced the Earl Carroll Theatre) on the walls and to suspend this ship model from the ceiling. The plan was abandoned when his architect said the walls and the roof were not up to the task.

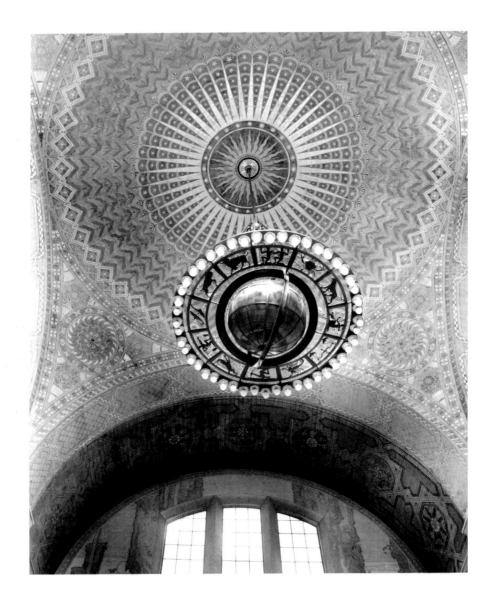

LOS ANGELES CENTRAL LIBRARY, 630 W. FIFTH STREET, 1926

The ceiling and globe in the rotunda were completely renovated, as were the Dean Cornwell murals depicting the history of California, after two fires devastated the building in 1986. The threat of demolishing this magnificent structure helped create the Los Angeles Conservancy in 1978.

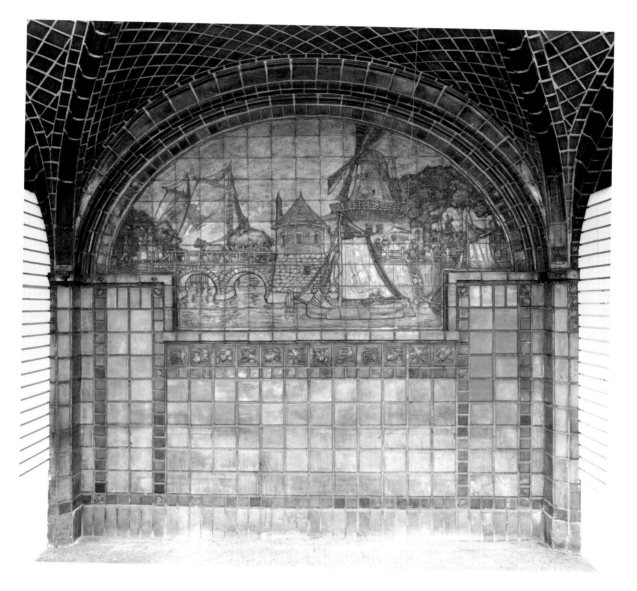

**DUTCH CHOCOLATE SHOPPE,
W. SIXTH STREET ARM OF THE BROADWAY-SPRING ARCADE BUILDING, 1913**

This was to be one of a chain of European-themed chocolate shops, but no other shops were ever built. The colored, Batchelder tile had to be coated in a uniform brown sealer, because the health department deemed the porous tile a hazard.

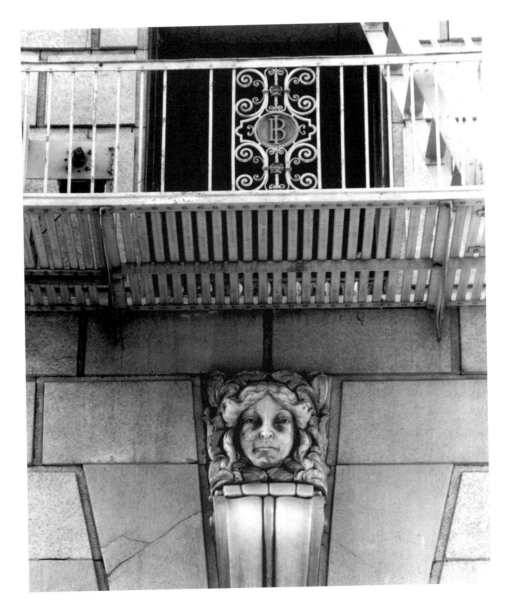

BANK OF ITALY / GIANNINI PLACE, 505 W. SEVENTH STREET, 1921

A.P. Giannini originally started his Bank of Italy in San Francisco, catering to fellow Bay Area Italians. In 1929, he merged with Los Angeles' Bank of America, which developed the concept of branch banking. The building became one of the new bank's many downtown structures.

96

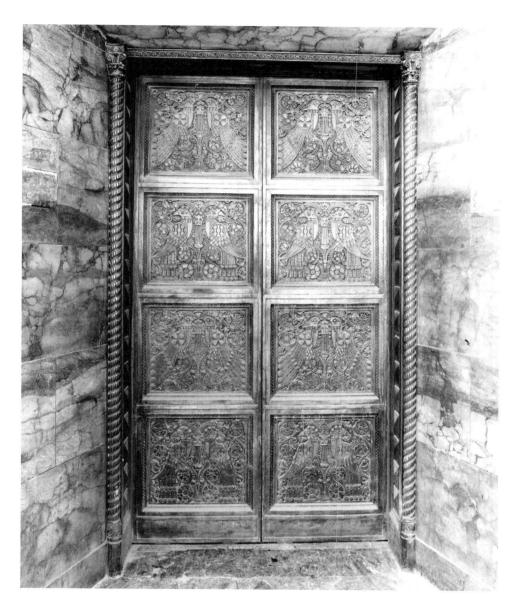

ROOSEVELT BUILDING, 727 W. SEVENTH STREET, 1923

Like so many of the other downtown office buildings, the Roosevelt Building has been rehabilitated into lofts. The street level was reconstructed to reflect the original design of the structure. The elevator doors are part of the rehab.

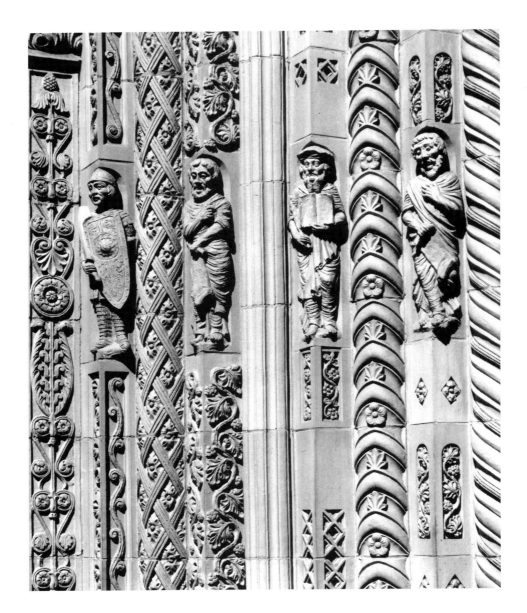

FINE ARTS BUILDING, 811 W. SEVENTH STREET, 1926

The Fine Arts Building was just that: it was constructed as a live-work space for artisans. The Depression killed that idea. It became the headquarters for the Signal Oil Company, where the only art going on was the production of *The Whistler*, the West Coast's most popular locally produced radio mystery program.

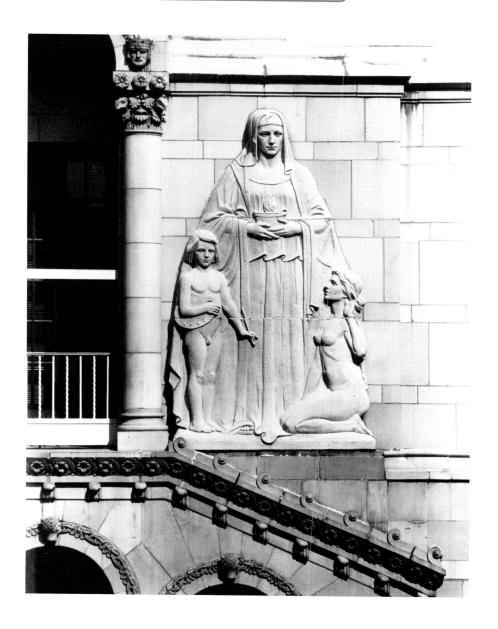

FINE ARTS BUILDING, 811 W. SEVENTH STREET, 1926

This mother figure is on the right side of the upper façade.

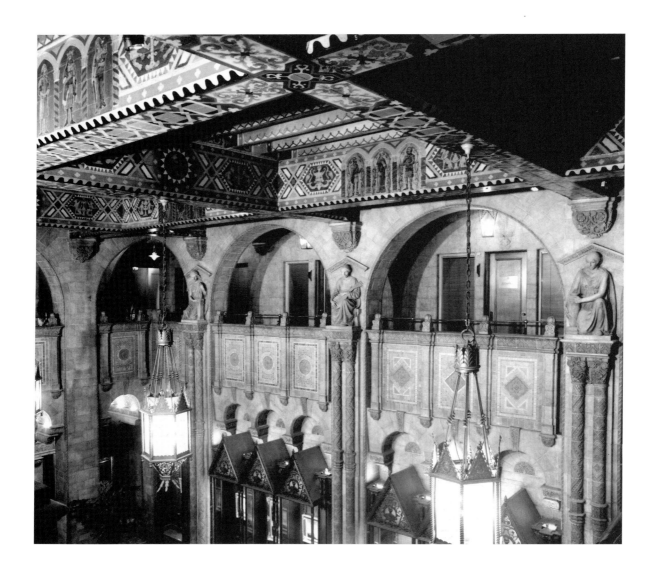

FINE ARTS BUILDING, 811 W. SEVENTH STREET, 1926

The two-story lobby was the largest commercial project ever undertaken by the Batchelder Tile Company. Larger-than-life-size female figures surround the mezzanine level.

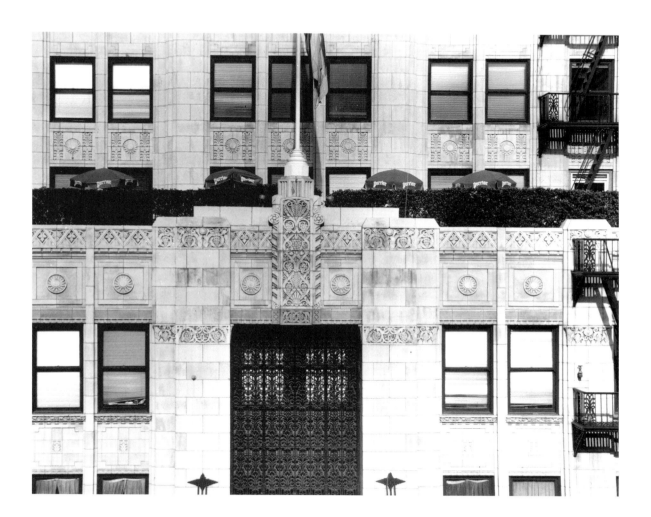

GARFIELD BUILDING, 408 W. EIGHTH STREET, 1929

This is another of Claud Beelman's Deco masterpieces.

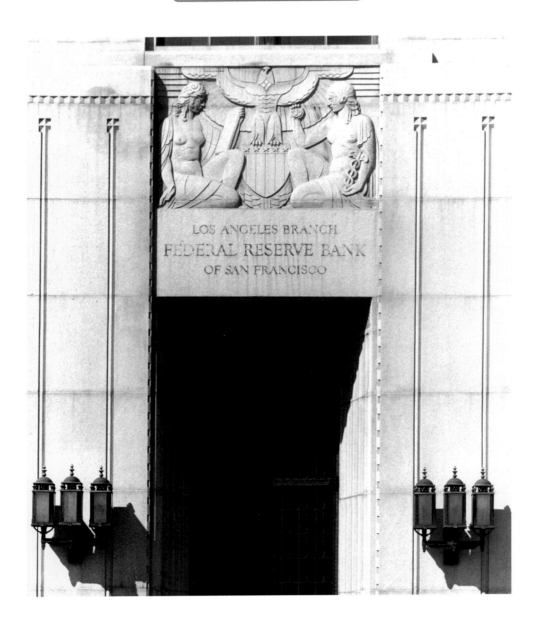

FEDERAL RESERVE BANK, 409 W. OLYMPIC BOULEVARD, 1930

Tenth Street was renamed Olympic Boulevard in honor of the coming 1932 Olympics. Edgar Walter created this relief sculpture representing Stability over the door. The building has been converted to housing.

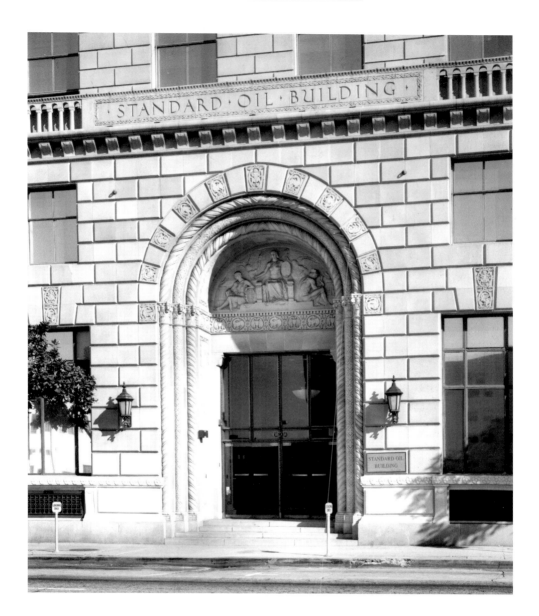

STANDARD OIL BUILDING, 605 W. OLYMPIC BOULEVARD, 1928

Architect George Kelham loved the Northern Italian Renaissance style he used on the Standard Oil Building. When it opened in 1928, the building was advertised as being Downtown, but out of the traffic of the Central Core and therefore easier to access.

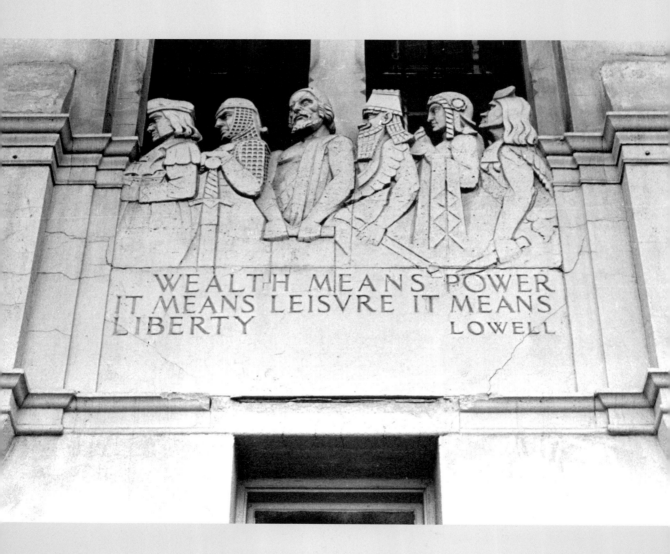

NATIONAL BANK OF COMMERCE, 439 S. HILL STREET, 1929-1930 (PHOTOGRAPH 1977, DEMOLISHED)

The bank's motto to the right of the main entrance is to the point. The bank was advertised as "adjoining the subway terminal."

LIST OF BUILDINGS AND LOCATIONS

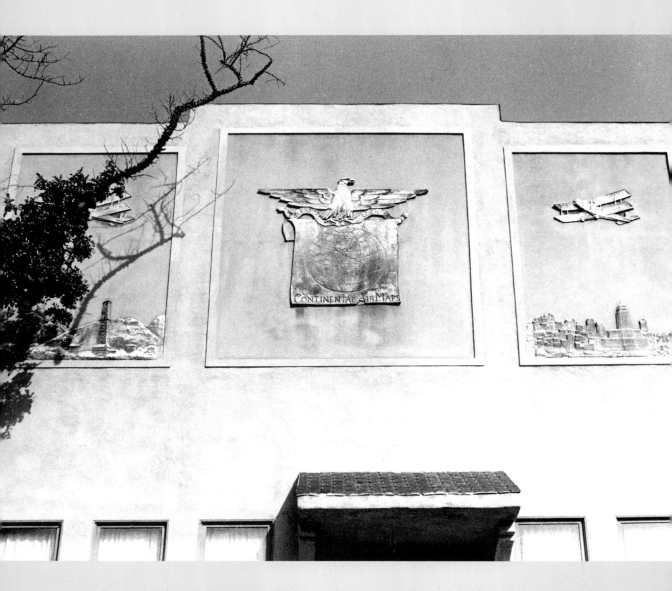

CONTINENTAL AIR MAPS, 114 S. BEAUDRY AVENUE, C. 1928 (PHOTOGRAPH 1978, DEMOLISHED)

Continental Air Maps did not survive the Depression, and there is no record of what became of its photographs. The last remaining collections of aerial imagery of Los Angeles are Spence Air Photos and Fairchild Aerial Surveys at the UCLA Department of Geography.

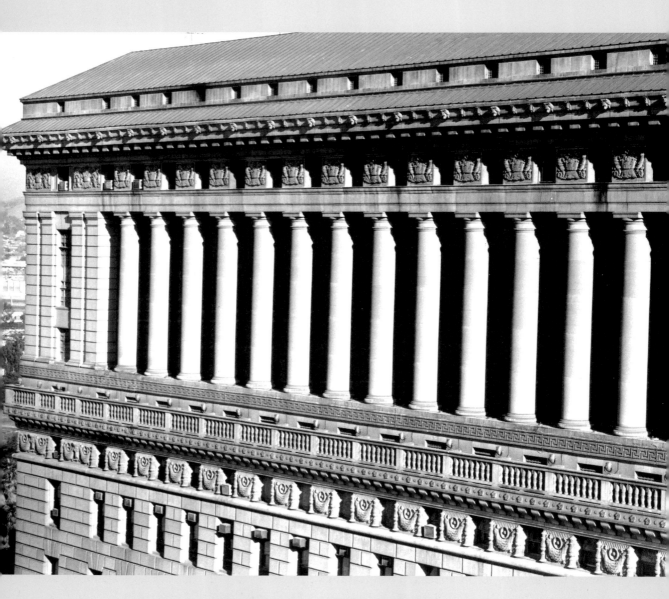

HALL OF JUSTICE, 210 W. TEMPLE STREET, 1925

The Hall of Justice and the Los Angeles River viaducts were about the only parts of the "City Beautiful" plan for the Civic Center that were realized in the 1920s. The three stories of columns mark the former county jail's lockup. The building was damaged by the 1994 Northridge earthquake and has been closed ever since.

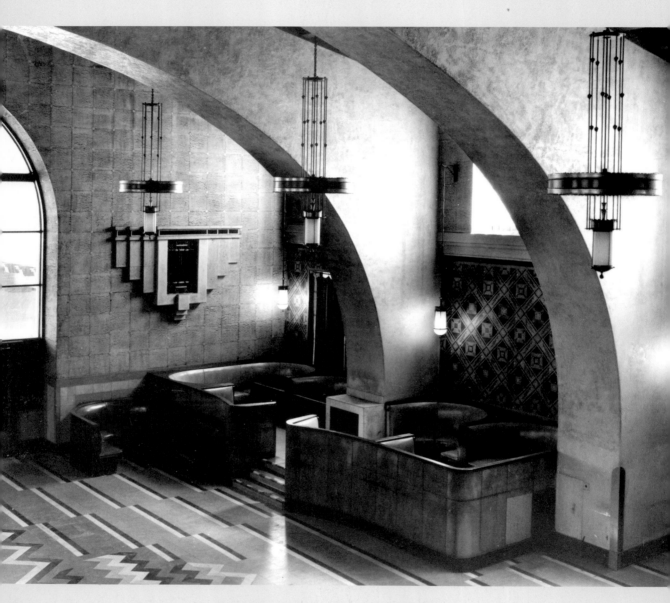

UNION STATION, 800 N. ALAMEDA STREET, 1939

In the Fred Harvey Restaurant, the Mission Revival-looking buttresses are purely decoration. Their fit with the Deco chandeliers illustrates the wonderful melding of the two styles found throughout the station.

FURTHER READING

General histories of Los Angeles architecture cover Downtown. See:

Gebhard, David and Robert Winter. *An Architectural Guidebook to Los Angeles*. Salt Lake City: Gibbs Smith, 2003.

Gleye, Paul. *The Architecture of Los Angeles*. Los Angeles: Rosebud Books, 1981.

Hatheway, Roger, Richard Starzak, Leslie Heumann, Tom Zimmerman. *Central Business District Survey*. Los Angeles: Community Redevelopment Agency, 1984.

Herr, Jeffrey, ed. *Landmark L.A.: Historic-Cultural Monuments of Los Angeles*. Santa Monica: City of Los Angeles Cultural Affairs Dept.: Angel City Press, 2002.

Moore, Charles, Peter Becker, and Regula Campbell, *The City Observed, Los Angeles: A Guide to its Architecture and Landscapes*. New York: Vintage Books, 1984.

Schwartzman, Arnold. *Deco Landmarks: Art Deco Gems of Los Angeles*. San Francisco: Chronicle Books, 2005.

More specific are:

Herman, Robert. *Downtown Los Angeles: A Walking Guide*. Baldwin Park: Gem Guides, 2003.

Roseman, Curtis, Ruth Wallach, Dace Taube, Linda McCann, and Geoffrey DeVerteuil. *The Historic Core of Los Angeles*. Mount Pleasant, SC: Arcadia Publishing, 2004.

Among specialized books there are two odes to demolished downtown masterpieces. There was no question that a true gem was being torn down when Morgan, Walls and Clements' Richfield Building was condemned. ARCO hired David Gebhard to write about it and Jack Laxer to photograph it. The result is *The Richfield Building, 1928–1968*. Los Angeles: Atlantic Richfield Co., 1970.

The County Hall of Records was built on a street that disappeared as did the building. It was commemorated by a small pamphlet: Whalen, Marie. *The End of an Era: Los Angeles County's Old Hall of Records, 1911–1973*. Los Angeles: County Board of Supervisors, 1973.

A suitably rapturous booklet was produced for the inauguration of City Hall, see:

Hales, George. *Los Angeles City Hall*. Los Angeles: Board of Public Works, 1928.

And another for the fortieth anniversary of Union Station:

Bradley, Bill. *The Last of the Great Stations: 40 Years of the Los Angeles Union Passenger Terminal*. Glendale, CA: Interurbans, 1979.

Two excellent photo books on the destruction of historic structures for redevelopment are:

Hylen, Arnold. *Bunker Hill, a Los Angeles Landmark*. Los Angeles: Dawson's Book Shop, 1976.

———. *Los Angeles Before the Freeways, 1850–1950: Images of an Era*. Los Angeles: Dawson's Book Shop, 1981.

Two excellent sources on individual buildings were the periodicals:

Los Angeles Saturday Night [a weekly]. Los Angeles Saturday Night Publishing Co.,1920-1939.

Southwest Builder and Contractor. 1917–1966. Imprint varies: 1917–1965, Iles-Ayar Pub. Co.

Several Web sites cover downtown buildings. See:

Los Angeles Conservancy resources at http://laconservancy.org/ and http://laconservancy.org/tours/tours_main.php4

"Downtown Los Angeles Map" at http://www.you-are-here.com/info/los_angeles_map.html

"Downtown Los Angeles Walking Tour" at http://college.usc.edu/geography/la_walking_tour/

"Public Art in Los Angeles" compiled by Ruth Wallach at http://www.publicartinla.com/

"A Visit to Old Los Angeles" by Brent C. Dickerson from the California State University, Long Beach Library at http://www.csulb.edu/~odinthor/socal1.html